Postcard History Series

Holyoke

POSTCARD HISTORY SERIES

Holyoke

Devon Dawson

Copyright © 2004 by Devon Dawson
ISBN 978-0-7385-3526-5

Published by Arcadia Publishing
Charleston SC, Chicago IL, Portsmouth NH, San Francisco CA

Printed in the United States of America

Library of Congress Catalog Card Number: 2003116189

For all general information contact Arcadia Publishing at:
Telephone 843-853-2070
Fax 843-853-0044
E-mail sales@arcadiapublishing.com
For customer service and orders:
Toll-Free 1-888-313-2665

Visit us on the Internet at www.arcadiapublishing.com

Contents

Acknowledgments 6

Introduction 7

1. Water Power and Industry 9

2. City Life 29

3. Recreation and Social Societies 67

4. Mountain Park and Mount Tom 83

5. Trolleys and Other Transportation 95

6. Hurricane and Floods 121

Acknowledgments

Although my name is on the cover, I can in no way take credit for all that went into creating this book. As with any work that attempts to draw on the collective history of a community, many people participated, either directly though their help or indirectly through the accounts they shared of the early days of the city.

First, I would like to thank all of the members of the history room staff for their continued support with this project. In particular, I would like to thank Jon Zwisler who has helped with each phase of this book from the very beginning. In addition, Sarah Campbell, David Matuszek, and Jennifer Geldart were always willing to help with research assistance and the seemingly endless fact checking that was required.

Additionally, I would like to thank the staff at the Wistariahurst Museum for their continued support of this project and the loan of the postcards of that beautiful mansion. I would also like to thank the Friends of the Holyoke Public Library for entrusting me with the task of completing this project and the library board of directors for their encouragement and support.

Although the history room has a large collection of postcards, the book greatly benefited from the generous loan of additional postcards from both Dan Griffon and Bob Fowler. Dan Griffon allowed me to borrow cards from his personal collection for use in the book, and Bob Fowler loaned me his annotated collection of postcards that were compiled by his late father, Frank Fowler. Without their contributions, the book would have been much narrower in scope, and for this I cannot thank them enough.

Most importantly, I want to thank my wife, Alta, for always being a source of encouragement to me even as my free time on evenings and weekends became increasingly scarce. When I felt like I would never finish you were always there to help me get back my perspective. And lastly, to anyone else I may have forgotten, you have my sincerest thanks.

INTRODUCTION

The city of Holyoke is located along the western shore of the Connecticut River between West Springfield and Northampton, and it is the first planned industrial city in the United States. When people have spoken of Holyoke, different images have been conjured at different times. Up until the 1840s, it was a rural community that subsisted primarily through fishing and farming. At this time, it was called Ireland Parish and was the northern part of West Springfield. Northampton Street, later called Route 5, was the center of the community, as it was the primary means of traveling between Connecticut and Vermont. Many of the oldest structures still standing in the city can be found along Route 5.

Everything changed in 1847, when the construction of the first Holyoke Dam began. Irish workers were brought in to build the dam and dig the canals. The initial construction on the canal system, which was dug by hand, was not completed until 1853, and many of the Irish workers and their families stayed on to work in the mills and other emerging industries. These Irish workers became the first ethnic population to settle in Holyoke and helped establish the city's long history of encouraging immigration.

By 1850, the community was incorporated into a town of 3,245 residents and had chosen to call itself Holyoke. Water power from the dam and canals allowed industry to thrive, and by 1873 Holyoke had become a city with a population of more than 11,000 residents. As industry continued to grow and new groups of immigrants, such as French Canadians, Polish, Germans and others, came to work in its many mills and businesses, the population continued to grow. By the early 20th century Holyoke was called the "Queen of Industrial Cities" and the "Paper City," and its population had swelled to more than 45,000 residents. The population peaked in the 1920s with more than 60,000 residents but has since steadily declined to around 38,000 today. Much of this was due to the increased availability of electricity, which powered mill machinery during the 1920s and made water-powered mills increasingly obsolete.

Today, Holyoke struggles to reinvent itself for the 21st century. The most recent immigrant population that has come to Holyoke emigrated from Puerto Rico, beginning in the 1960s. Differences in language and culture are nothing new to a city that was built upon immigration, but change is seldom easy. During the 1970s and 1980s, Holyoke was marked by high crime and poverty rates, which gave the city a stigma that remains even today. Holyoke, however, has been fortunate that its current mayor and other city officials value its rich past as they plan for the city's future. As we move forward into the 21st century, new businesses, renovated homes, and revitalized neighborhoods are becoming Holyoke's present.

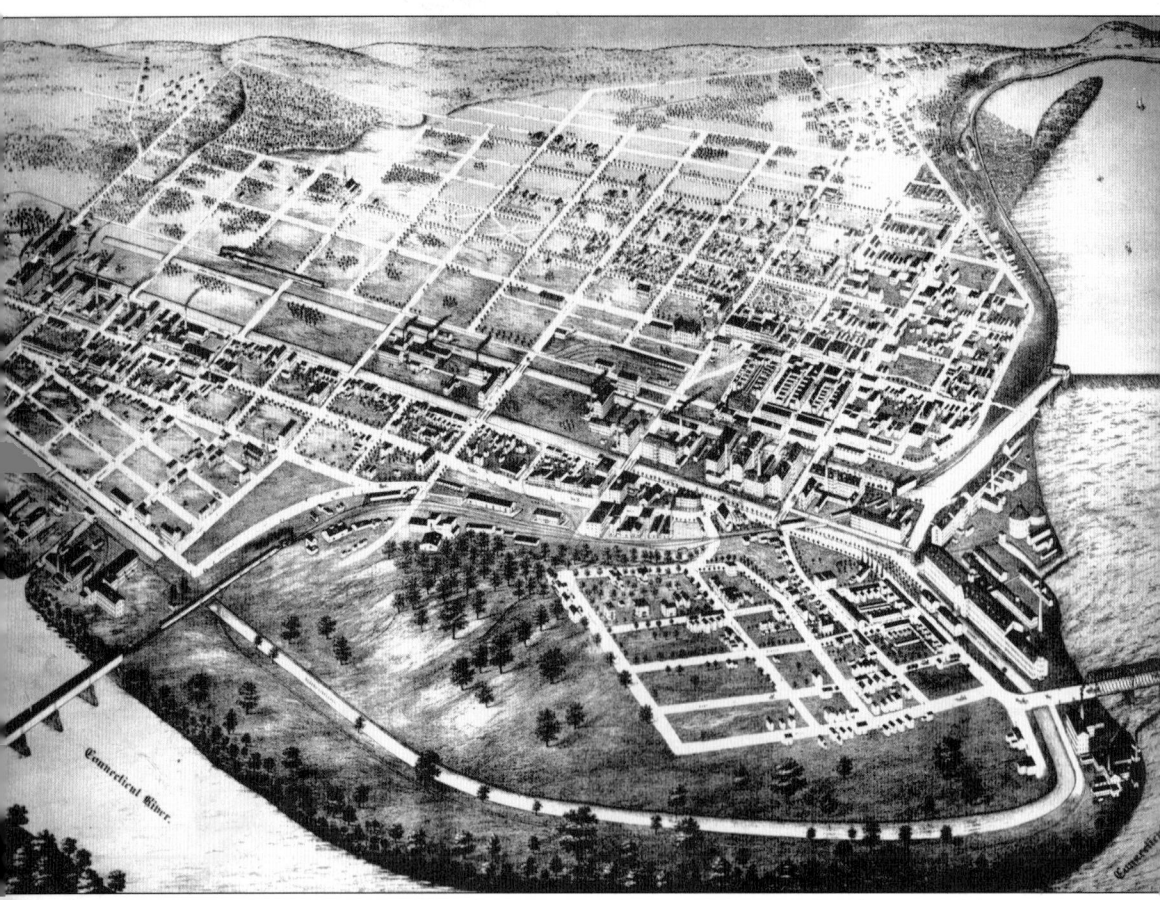

This is an 1877 map of Holyoke that shows many of the major geographic features of the city. In the upper right corner is Mount Tom, off in the distance. Traveling down the Connecticut River along the right side of the map, one first comes to the dam and then the Holyoke–South Hadley Bridge below it. Shown just to the left of the dam is a small building; it is the gatehouse for the canal system. From there, one can see the canals as they cut across the lower section of the city.

One
Water Power and Industry

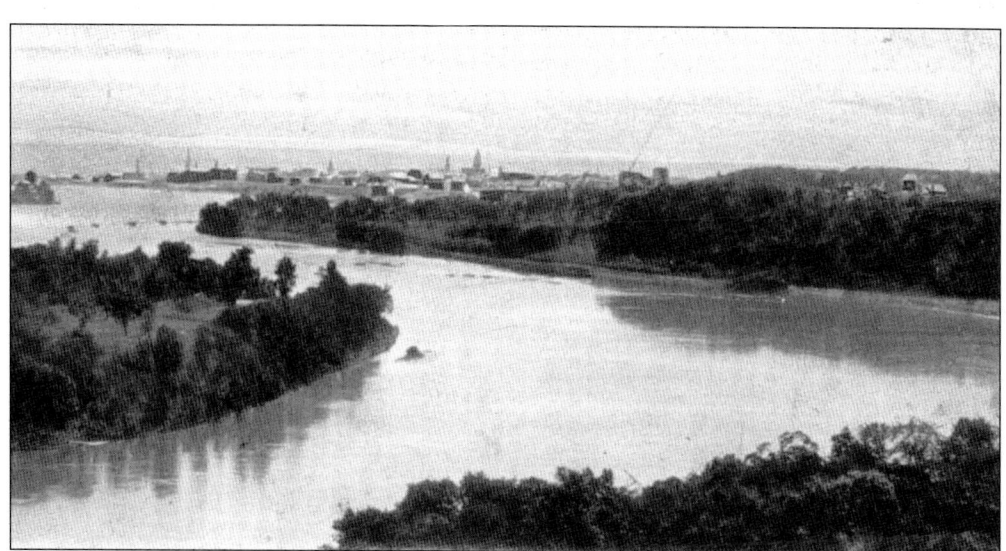

This is a southerly view of Holyoke and the Connecticut River from the approximate location of the present Route 202. The island to the left of the picture was simply called "the island" and has since been connected to the riverbank by a landfill that made a cove of the area and water viewed here.

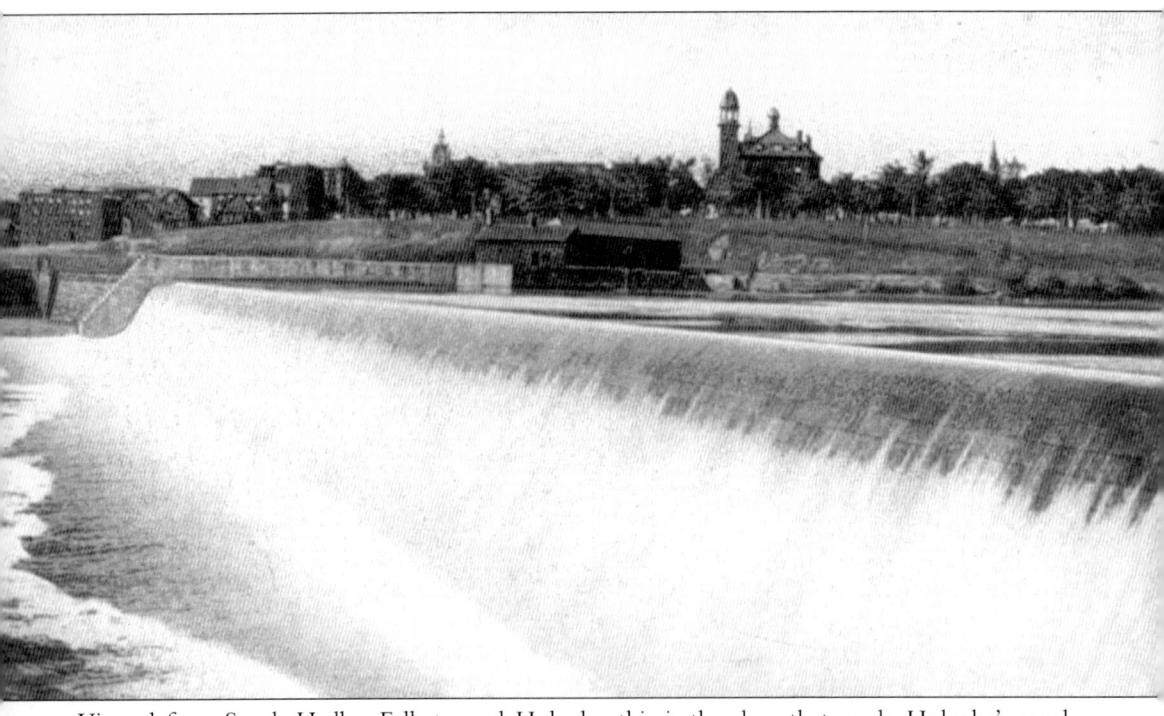

Viewed from South Hadley Falls toward Holyoke, this is the dam that made Holyoke's canal system possible. At 1,020-feet long, it was considered the longest dam in the world for several decades after it was completed. The dam seen here is actually Holyoke's third dam. The first one was made of wood and broke within hours of being completed. The second was also made of wood but held. And the third dam, seen here, was made of granite, was completed in 1900, and still stands today. The gatehouse can be seen above the waterline in the center of the postcard.

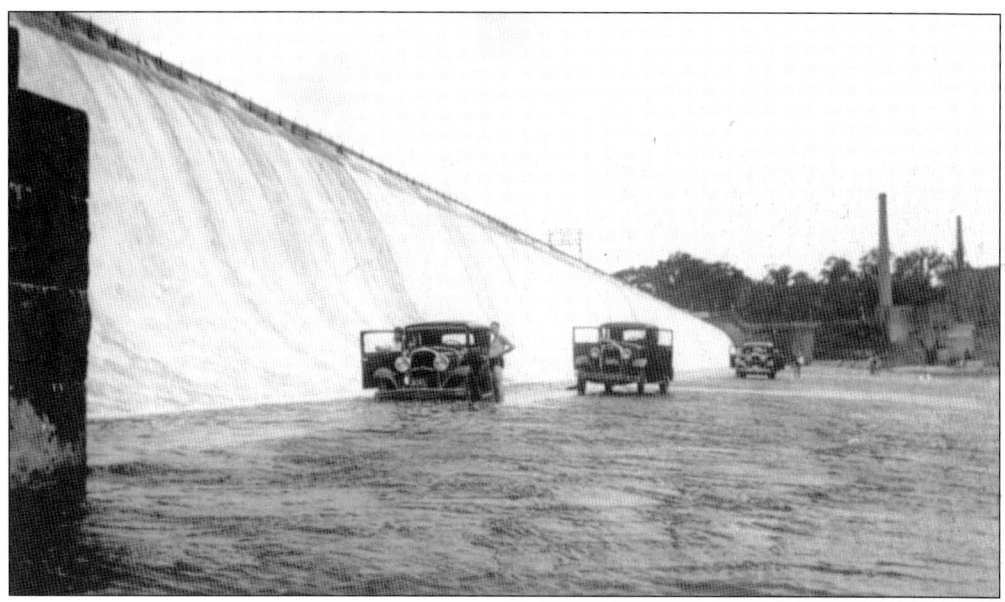

This 1937 postcard shows a popular summer pastime for a few brave Holyokers. These people drove to the base of the dam to wash their cars with the river's immense power roaring beside them.

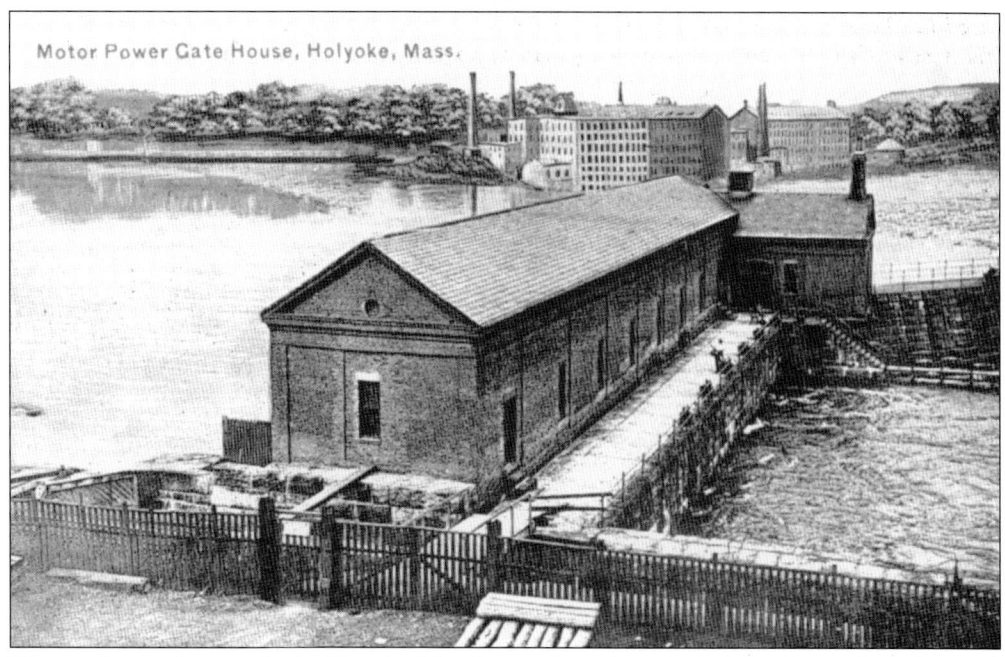

The gatehouse sits atop the bulkhead of the dam and regulates the influx of water into the canal. This was accomplished by controlling its 12 gates, which were opened at any given time to regulate the flow and depth of the canals.

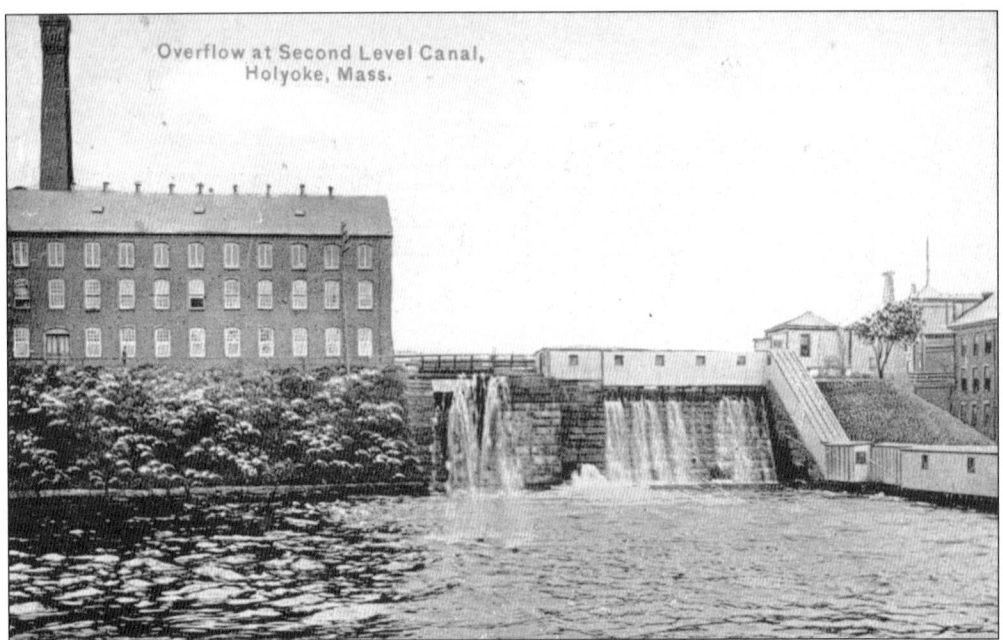

Here is where the first canal overflows into the second-level canal. The canals were built on three levels and use gravity to move the water though them. The total drop from the entrance at the gatehouse to the final exit into the Connecticut River is 56 feet.

Originally, the city took its municipal water supply from the Connecticut River via a waterwheel-driven pump at the canal system's gatehouse. In 1871, it was decided to change the location of the city's water supply from the river to Ashley and Wrights Ponds, above the city in the highland area just south of Mount Tom. In 1899, as the city's water demands grew, construction began on a high-pressure reservoir off of Wrights Pond.

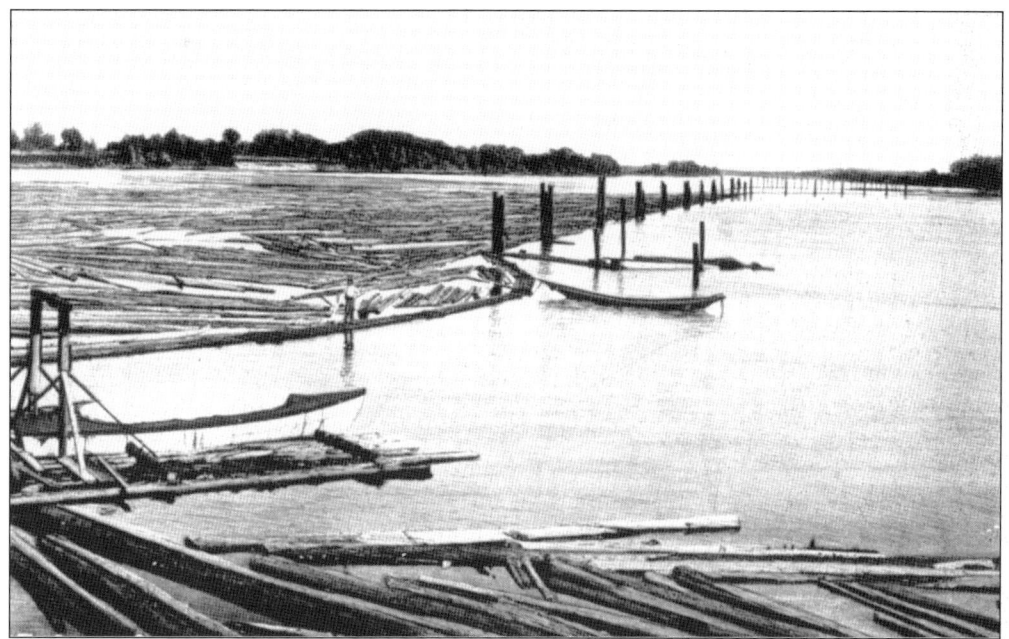

Early in the 20th century, log drives were common along the Connecticut River, but the practice ended in 1915. This log boom stretched between the island and the riverbank to contain the logs for use by the Connecticut River Lumber Company.

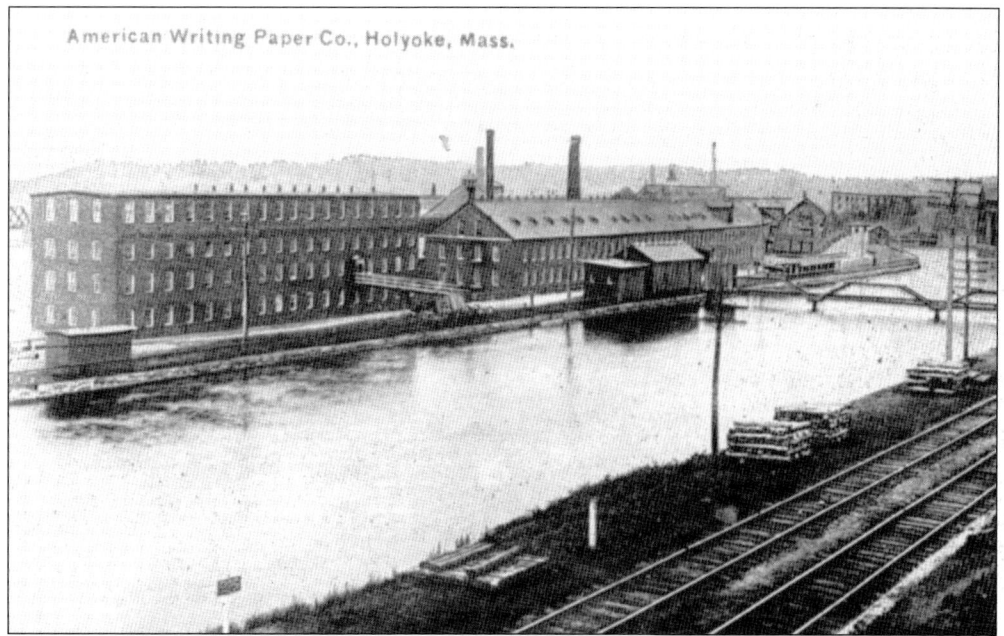

The American Writing Paper Company was founded in 1899. The mill itself was built in the 1850s, along with many of the other mills that use Holyoke's canal system. The paper mill pictured here was located on Gatehouse Road and produced quality writing paper products until it was sold to the Brown Paper Company in 1952.

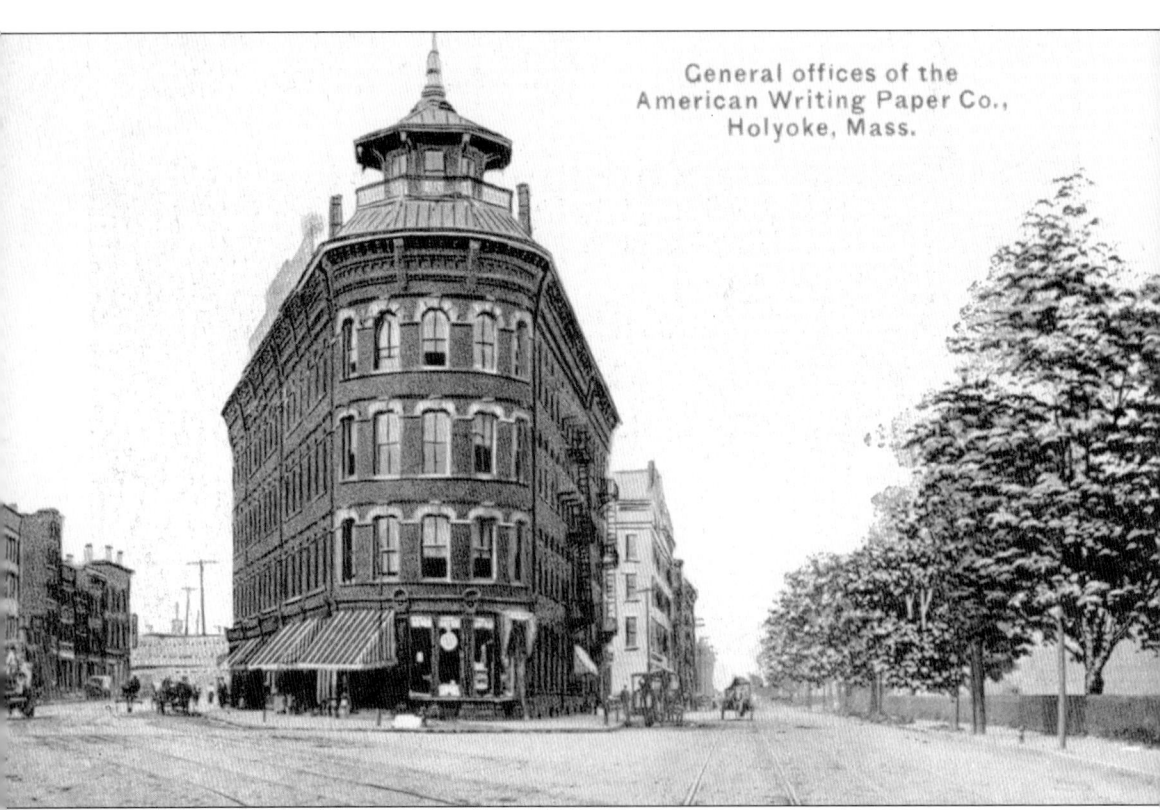

Located at the intersection of Race and Main Streets, this building was nicknamed "the Flatiron" because its shape resembled that of a household iron. It was built by the Parsons Paper Company in the late 1870s as a tenement with stores located on the main floor. After the American Writing Paper Company formed in the 1890s, it located its general offices here, where they remained until 1952, when the offices were relocated to one of their mills. The building, although unique in design to Holyoke, was left vacant and torn down that same year.

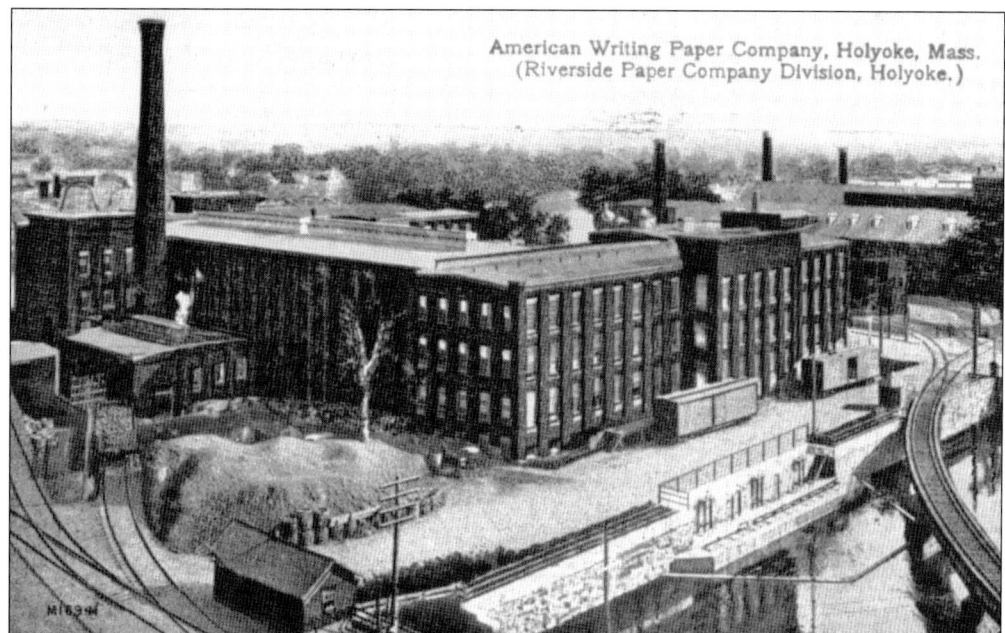

The Riverside Paper Company was one of 26 Holyoke paper mills incorporated in 1899 to form the American Writing Paper Company. The consolidation was meant to make Holyoke's diverse variety of paper mills more competitive nationally. As shown here, the various companies were generally retained as divisions of the American Writing Paper.

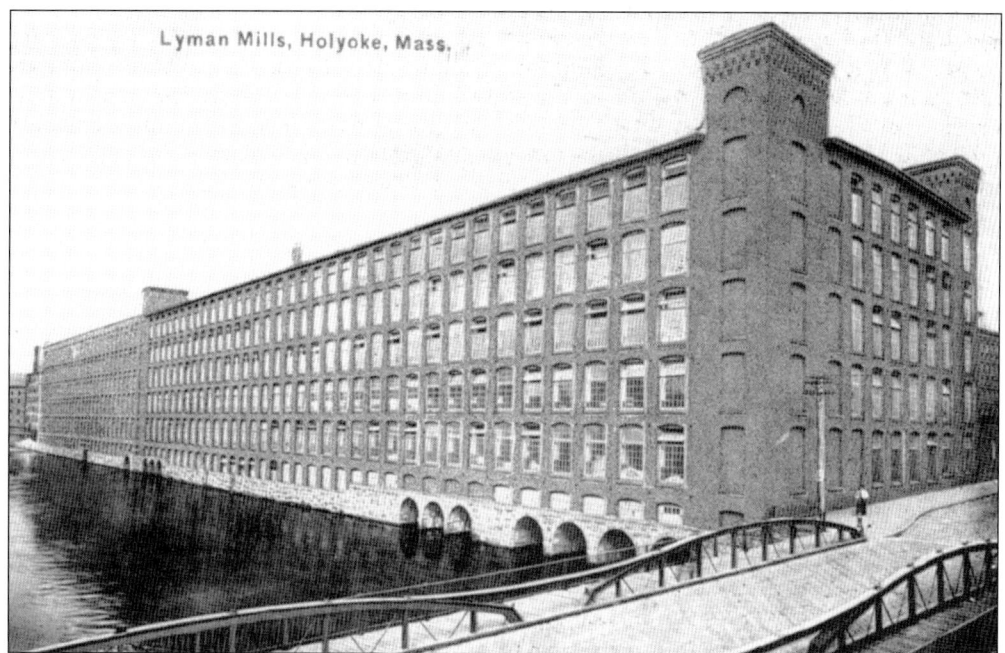

The Lyman Textile Mills were one of the early success stories in Holyoke. Started in 1854, they addressed early labor shortages in Holyoke by actively recruiting French Canadians to come to the city to work in their mills. Lyman mills continued to expand throughout the 19th century. Pictured here is their third mill, No. 3, built in 1872.

After losing his silk manufacturing mill in Williamsburg to a flood in 1874, William Skinner relocated his company to Holyoke and became one of the most successful businessmen in the city's history. A fire destroyed the mill, pictured here, in July 1980, and it is currently the site of Heritage State Park.

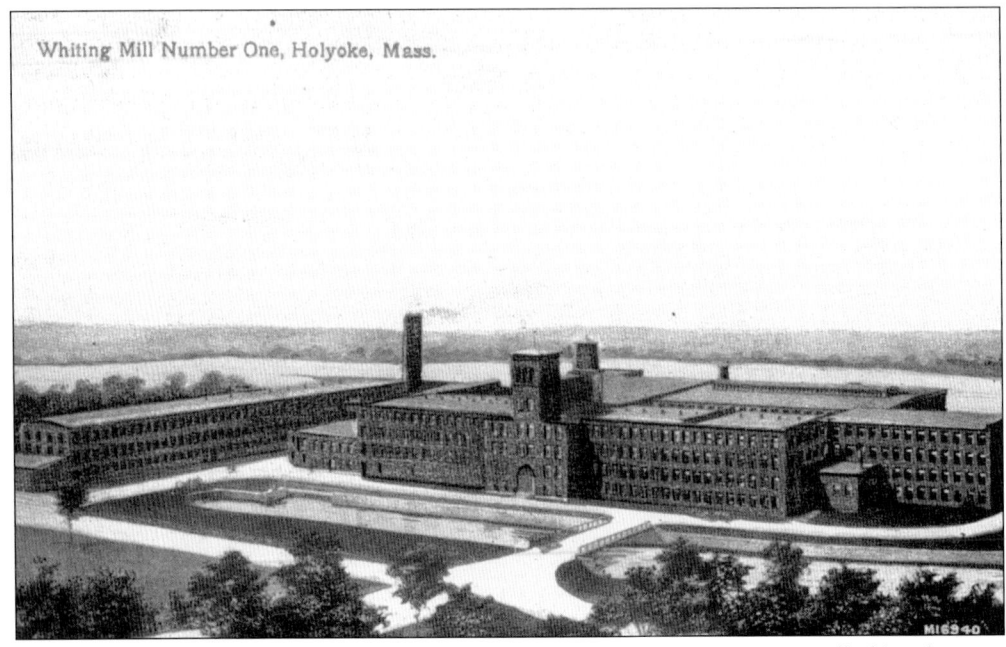

William Whiting founded the Whiting Paper Mills in Holyoke in 1865. Mills like this one were very successful, and his was one of the few that did not join the American Writing Paper Company. William Whiting was a success outside of the paper business as well and was elected mayor in 1878 and to Congress from 1883 to 1889.

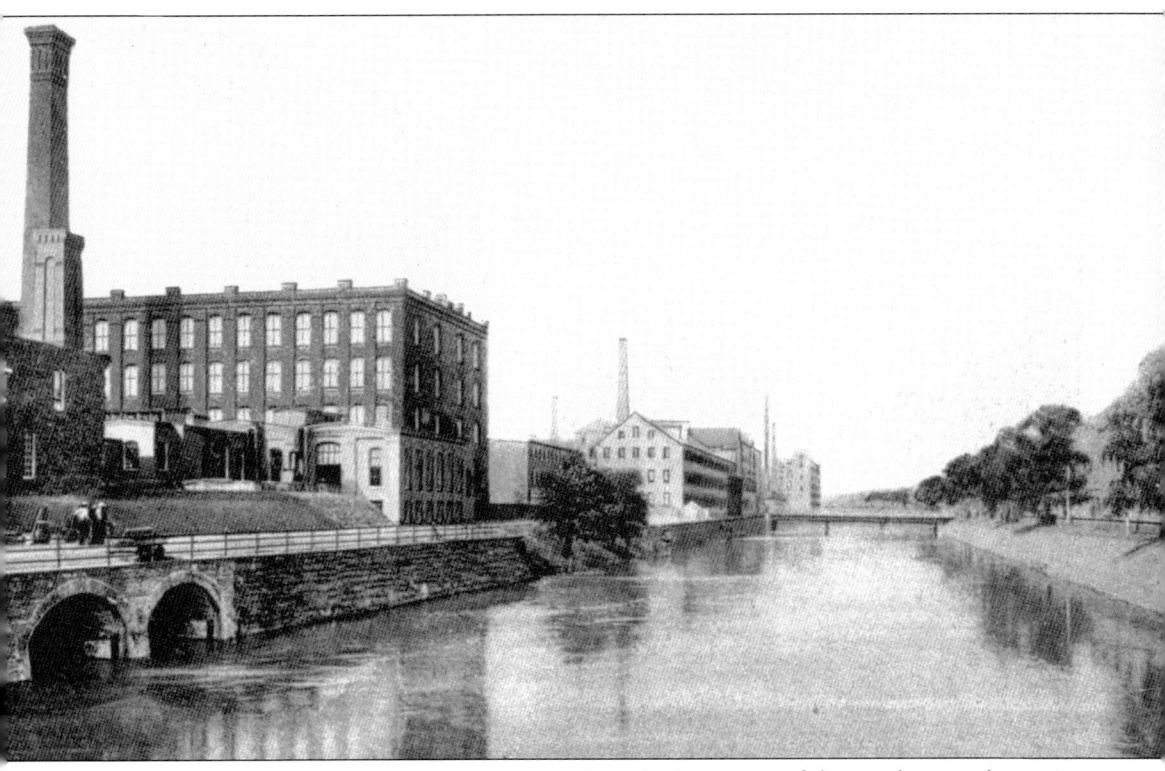

Looking north, this is a view of the second-level canal. The survey of the canal system began in 1847. The four and one-half miles of canal were dug by hand, and the stone for the canal walls was quarried locally. The parallel canals were built to allow gravity to move the water though the system. The second canal was built 20 feet below the first, and the third canal was built 12 feet below the second level. This enabled water to pass through the portholes in the mills' foundations, thereby powering the turbines that operated the machinery in the mills above.

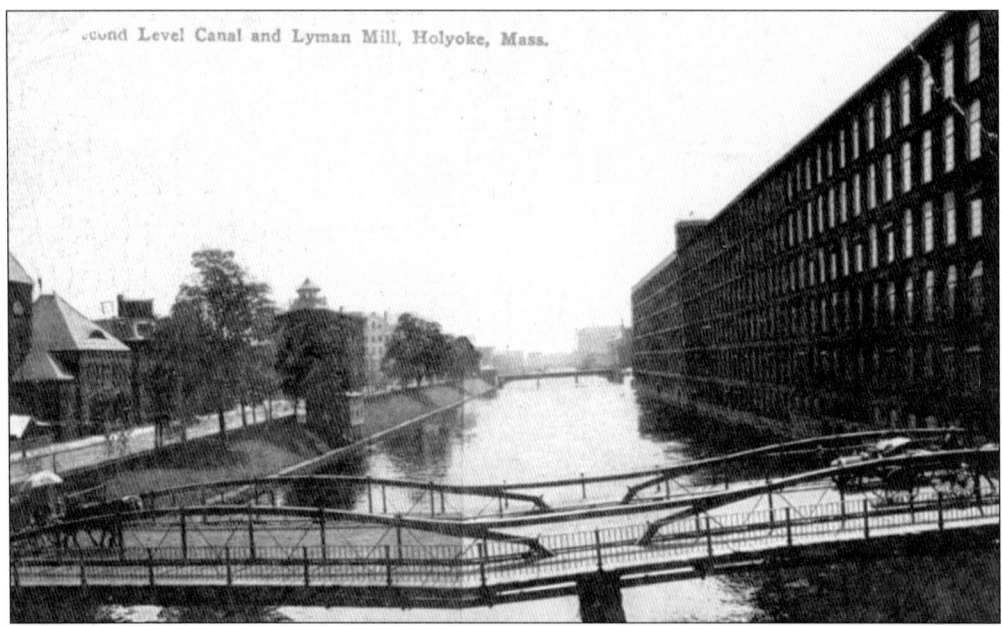

This image shows the area of the second, or middle, canal near one of the Lyman Street canal bridges. On the right is Whiting Paper Mill No. 3, and on the left are two buildings significant to Holyoke's history. Along the left bank of the canal, one can see the headquarters of the Holyoke Water Power Company and, just beyond it, the top of the Flatiron building.

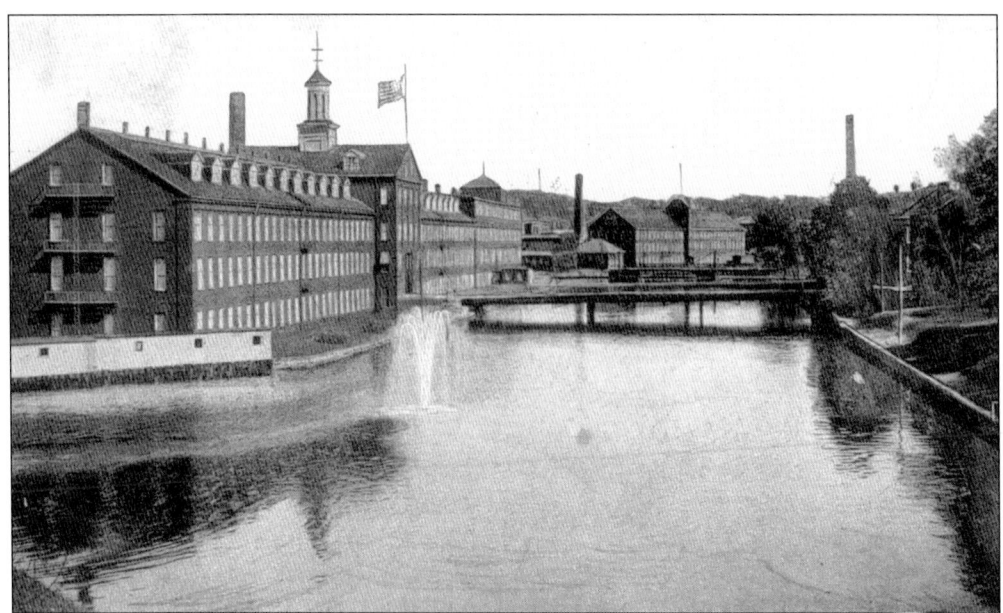

The Hadley Mills Company manufactured quality clothing from cotton, linen, and silk. Shown in the far background is the Valley Paper Company.

This is another view of the Hadley Mills Company. In the center one can better see the footbridge that was used by mill workers crossing to the mill from Canal Street.

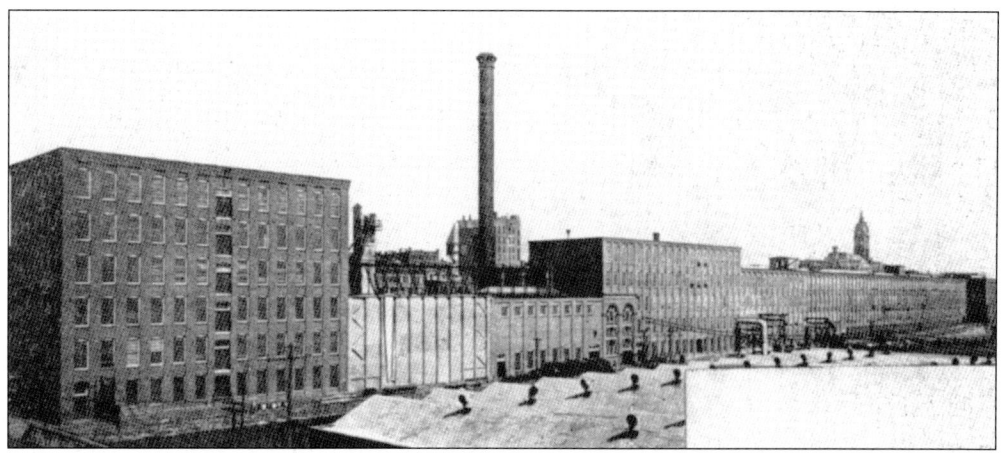

This is a canal-side view of the Farr Alpaca Company mill complex as viewed from the Cabot Street Bridge. Farr Alpaca was a major employer in Holyoke throughout the 20th century and produced alpaca, serge, and worsted dress coats.

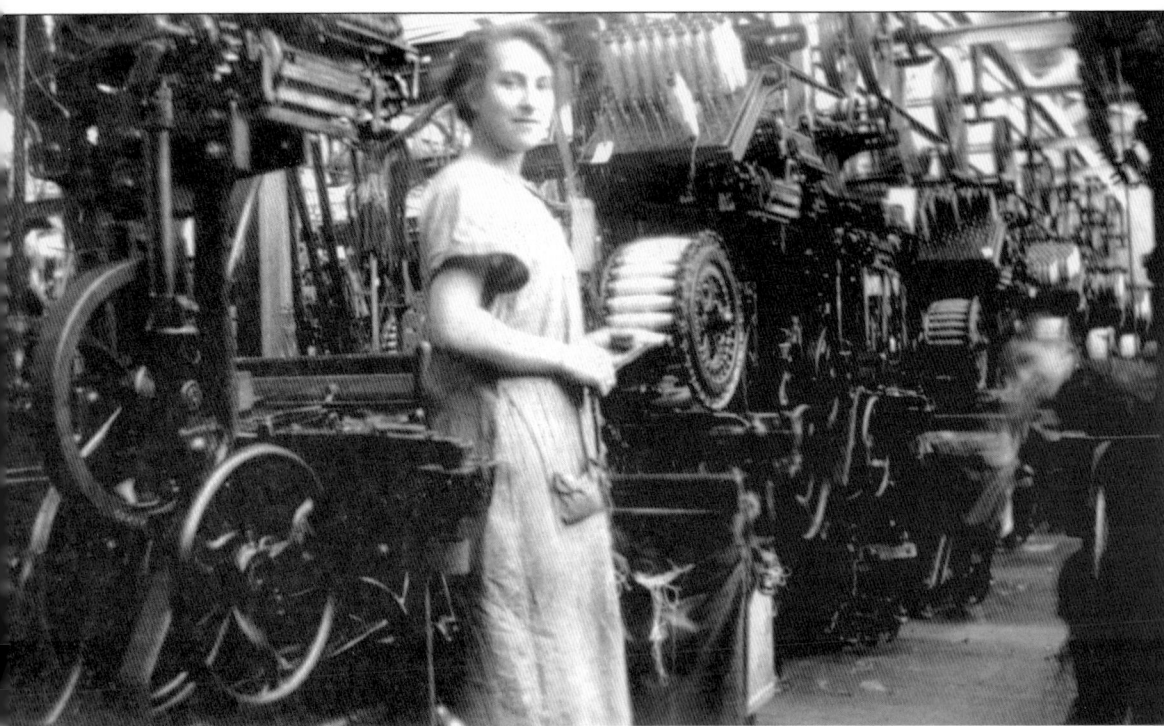

This card shows the interior of one of the Farr Alpaca mill buildings from 1915. The mills were hot and extremely loud. Many of the workers, such as the one in the foreground, would use hand signals to communicate with others at nearby stations so they could be understood when the machinery was in operation. Life was not easy for the mill workers in other ways as well. The normal workweek was from Monday to Saturday, and the workday started at 5 a.m. and ended at 6:30 p.m. with only a half-hour break for breakfast and dinner. The workers generally lived in tenement apartments that were owned by the mill company and located within walking distance of the mill.

The Merrick brothers came to Holyoke from Mansfield, Connecticut, in 1864, when drought conditions slowed the flow of many of the smaller rivers along the Connecticut Valley. Holyoke, however, advertised the continued supply of regulated water to its canals and drew many new manufacturers during this period. The brothers formed the Merrick Thread Company, and by 1866 the building pictured here was completed.

This fellow with his heavy coat, overshoes, and team of horses is ready for a day's work. The railroad track and telegraph pole at the right suggest that he was probably working along the Northampton Highway, the present Route 5.

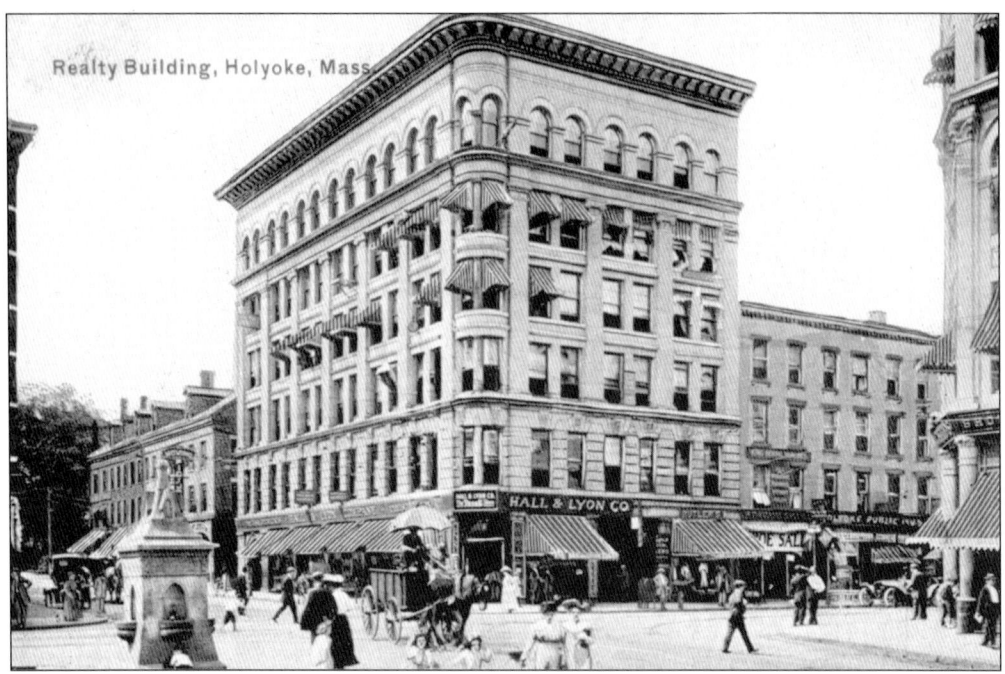

The Realty Building was constructed in 1898 and sits diagonally across the street from city hall. It has recently been renovated and is in use today. In the foreground at the bottom left of the postcard, one can see the public drinking fountain made of Monson granite that was located in front of city hall and was a gift from the Temperance Union in 1901.

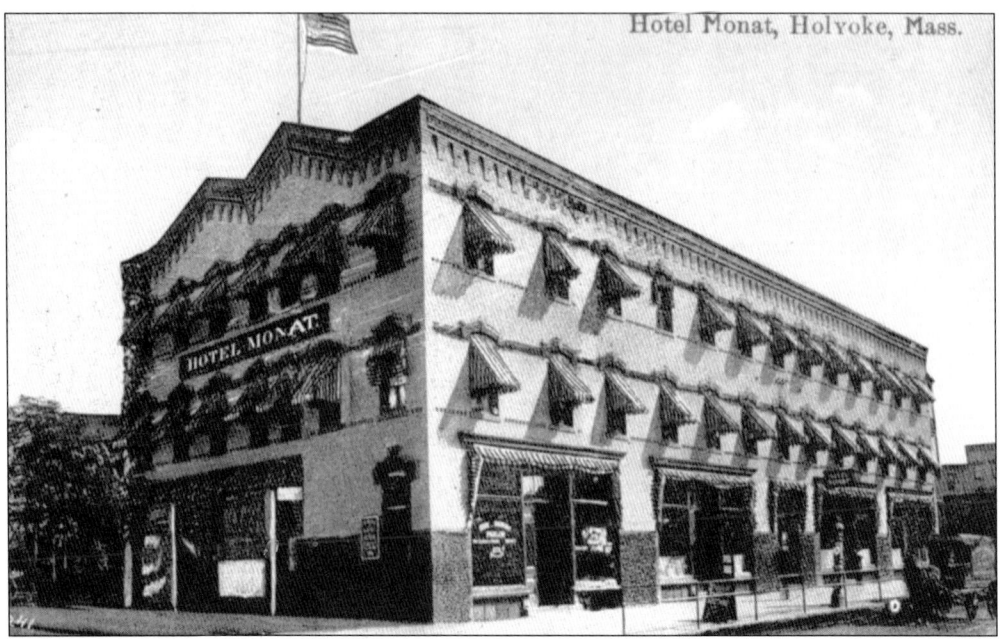

The Hotel Monat opened in 1886 as an eight-room hotel called the Norris House. When Henry Monat bought it in 1906, he renamed it the Hotel Monat and enlarged its size to 42 rooms. Located at Main and Mosher Streets near the Boston and Main Railroad station, it was a convenient stop for travelers. It later fell into disuse and was torn down in 1982.

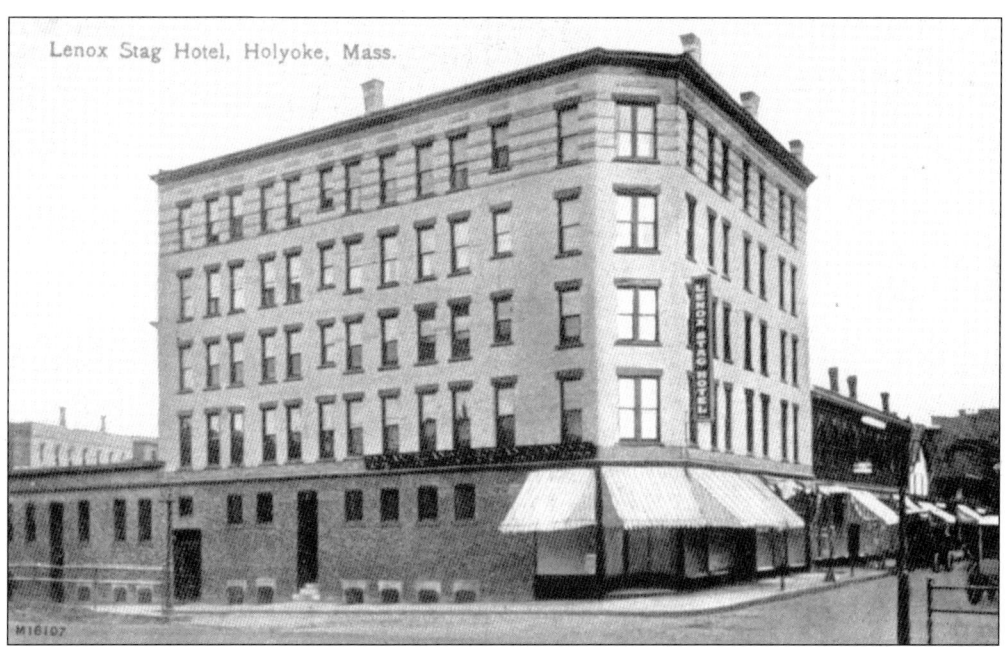

Another hotel near the Boston and Main Railroad station was the Lennox Stag Hotel, at 109 Ely Street. Built in 1913, the Lennox Stag Hotel, like the Hotel Monat, served as a convenient location for travelers along the railway. Unfortunately, it shared the same fate as the Monat and is no longer standing.

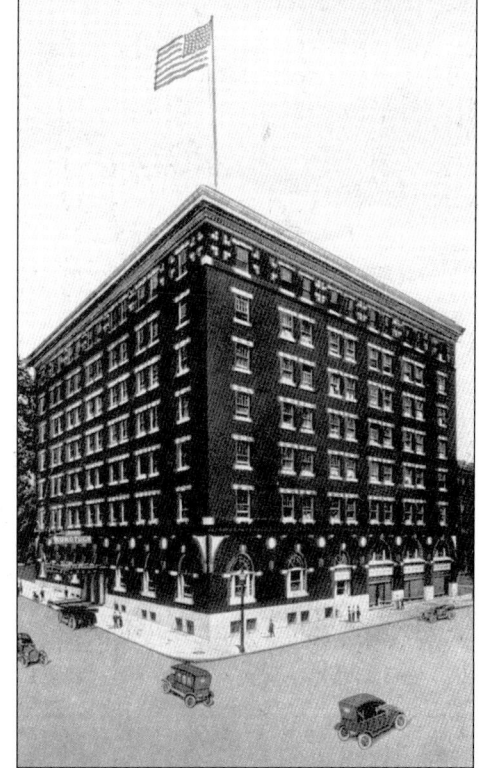

When the hotel shown in this image first opened in 1915, it was called the Nonotuck Hotel. It had a restaurant, with a roof garden, known as the Indian Garden and a dance floor with a breathtaking view of the Pioneer Valley. It was later turned into one of six Roger Smith Hotels located on the East Coast.

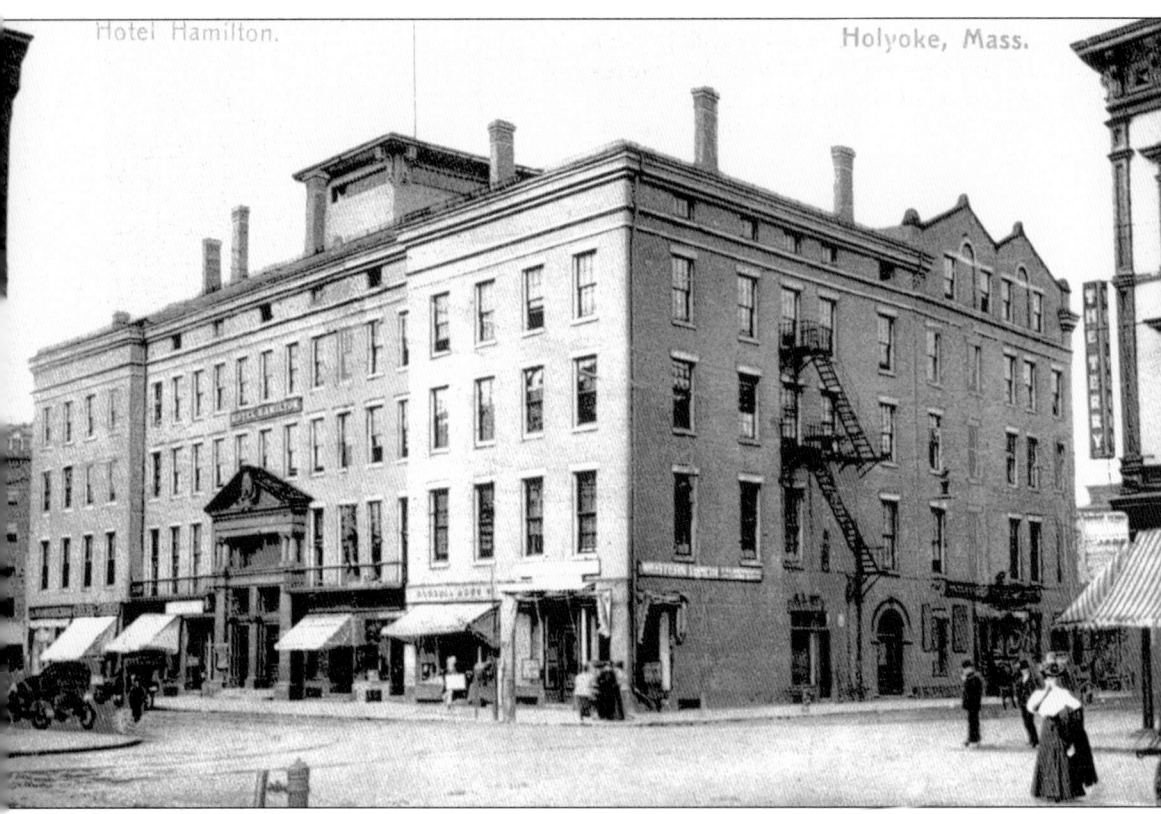

Located at Main and Dwight Streets, the Hotel Hamilton was first called the Holyoke House and was built shortly after the town of Holyoke incorporated in 1850. An early example of the deluxe accommodations that could be found in the city, the original advertisements hailed it as as fine as any hotel in Boston. The building was purchased in 1911 by Joel Russell, and it became the site of the J. Russell Hardware Company. Today, the building stands but is partly vacant; the rest of it is used by various social service agencies.

The La France Hotel was built by Louis La France in 1901. Its location across High Street from the Empire Theatre made it a favorite among the actors and actresses performing in the city. It later became the Hotel Essex.

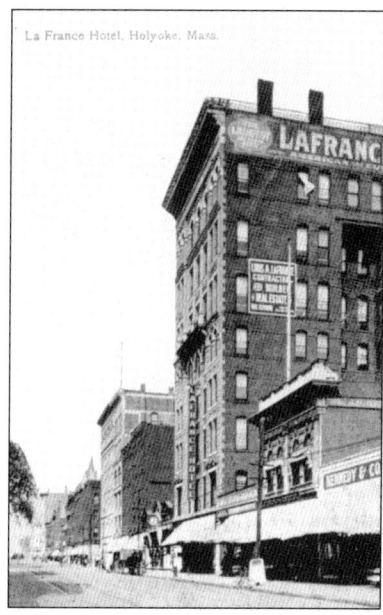

Medric Laporte bought this building in 1900 to use for his livery, boarding, feed stable, and hack service business. A blacksmith shop and wagon repair shop were on the first floor, horses were stabled above on the second floor, and the upper floors were used for his moving and storage business. Although the building is gone, the site is now the location of a city-owned parking garage.

The Marble Building was built by John Delaney in 1885 as a hotel and was located directly across Dwight Street from city hall. The marble used in its construction came from a Vermont quarry owned by the Proctor family, one of which was the governor of Vermont. When the governor stopped in Holyoke, he would pass by the Marble Building to "see how his marble weathered." The marble weathered well, but owners wanting a more modern-looking building had it torn down in 1950, and its marble was hauled across the river to South Hadley and used as landfill.

This postcard is an advertisement for the Naumkeag Clothing Company, which was located at the corner of High and Suffolk Streets. Initially, it was poorly managed and had a troublesome staff. In 1892, August Gallup began running the business. He revitalized the store and in 1906 purchased it and renamed it A. T. Gallup Clothiers.

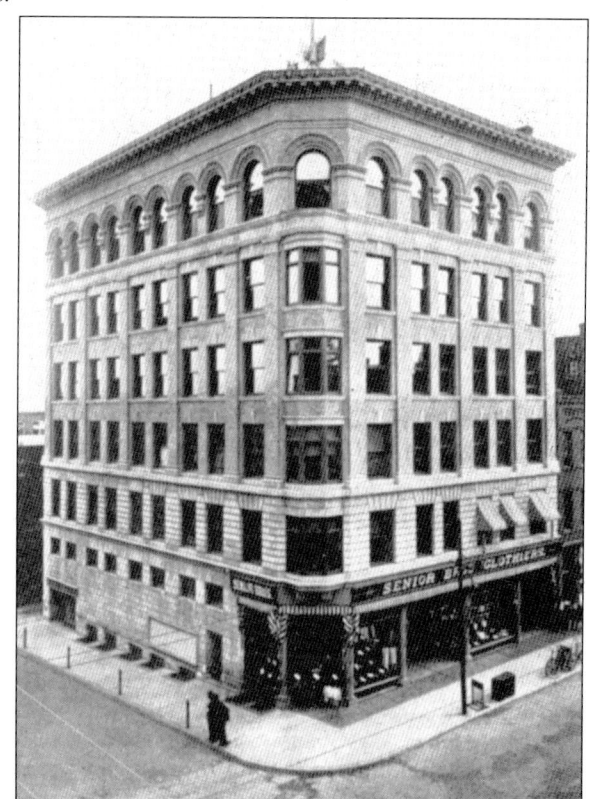

Senior Brothers Clothier was located at the corner of High and Appleton Streets. The property was bought by Henry M. Senior in 1898, and the building was built shortly thereafter. It was a multiuse building, with the clothing store occupying the first floors and the upper floors used as office space.

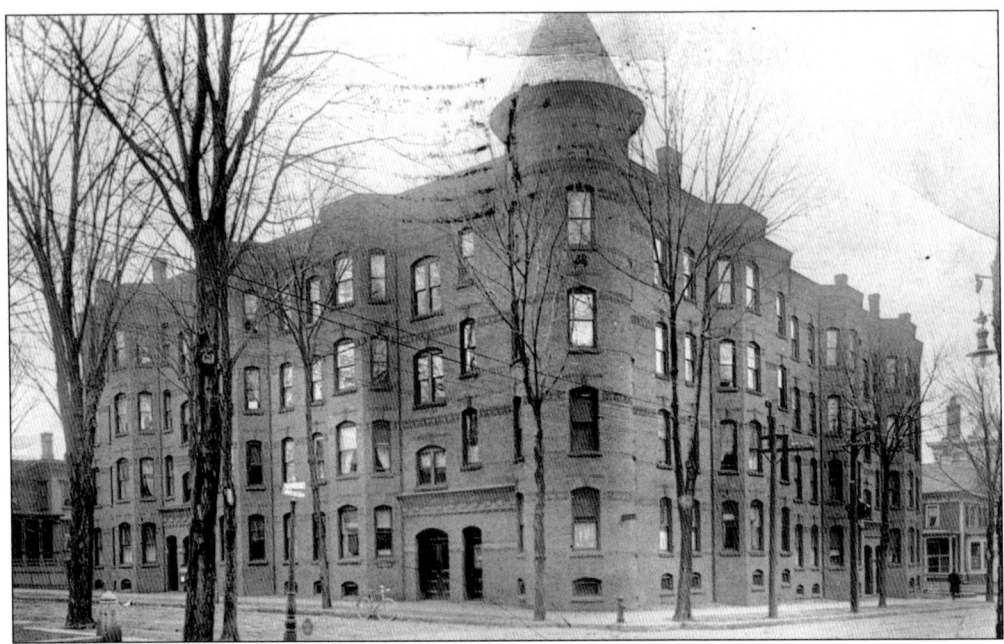

The Trowbridge Apartment House, located at the corner of Appleton and Chestnut Streets, was typical of the apartment houses within the city that were a step-up from the tenement housing occupied by many of the mill workers and their families.

Although it is difficult to see from this card, Dwight Street crosses both the first- and second-level canals between Main Street, shown in the foreground, and High Street, which can be recognized from the location of city hall's clock tower.

Two
CITY LIFE

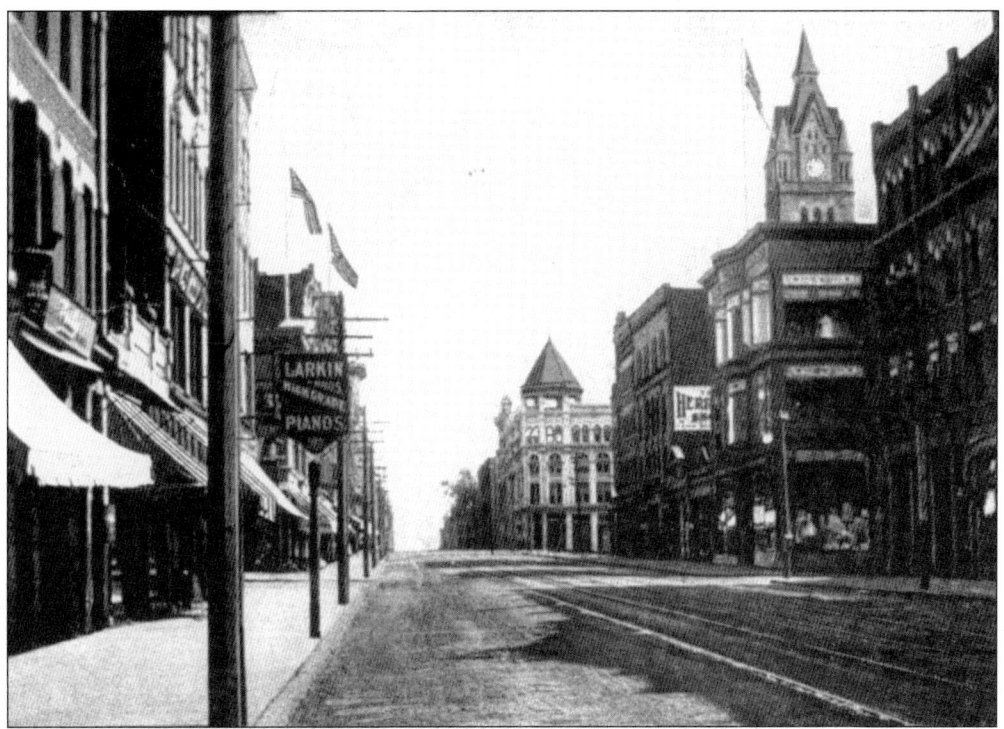

This view looks north along High Street from its intersection with Suffolk Street. City hall's tower and the Marble Building can be seen on the right side, and a marquee for Larkin Pianos can be seen on the left. Larkin Pianos was a manufacturer of quality pianos and organs from 1891 to 1929.

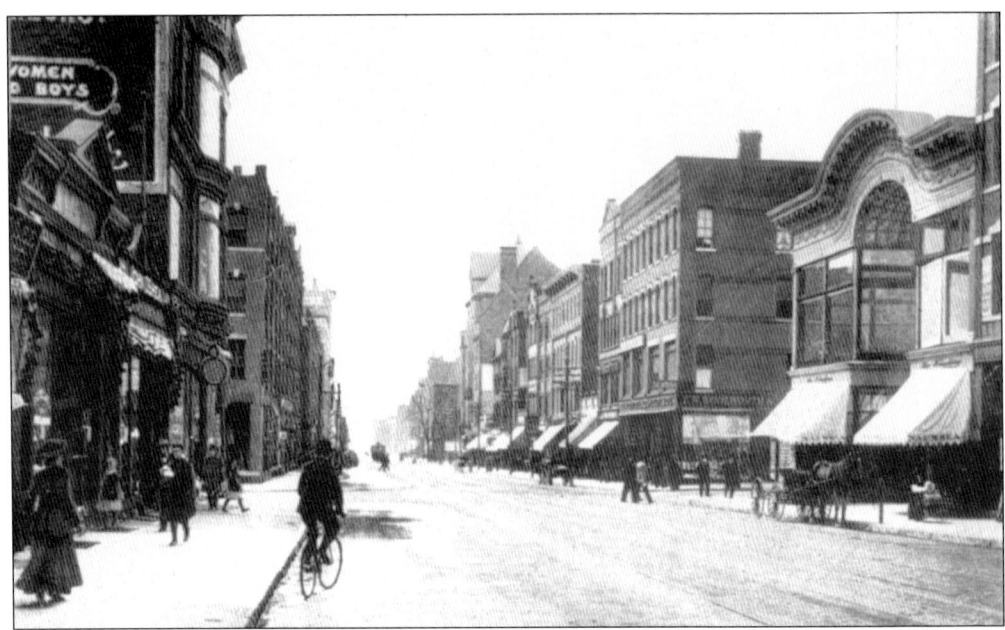

Looking south along High Street from the front of city hall one can see the Bessie Mills and C. J. Callup stores on the left and the Naumkeag building on the right. Farther down on the right, the Young Men's Christian Association (YMCA) can be seen at the corner of Appleton Street. The cards of High Street, along with those of city hall, clearly show that High Street was the actual downtown area of the city.

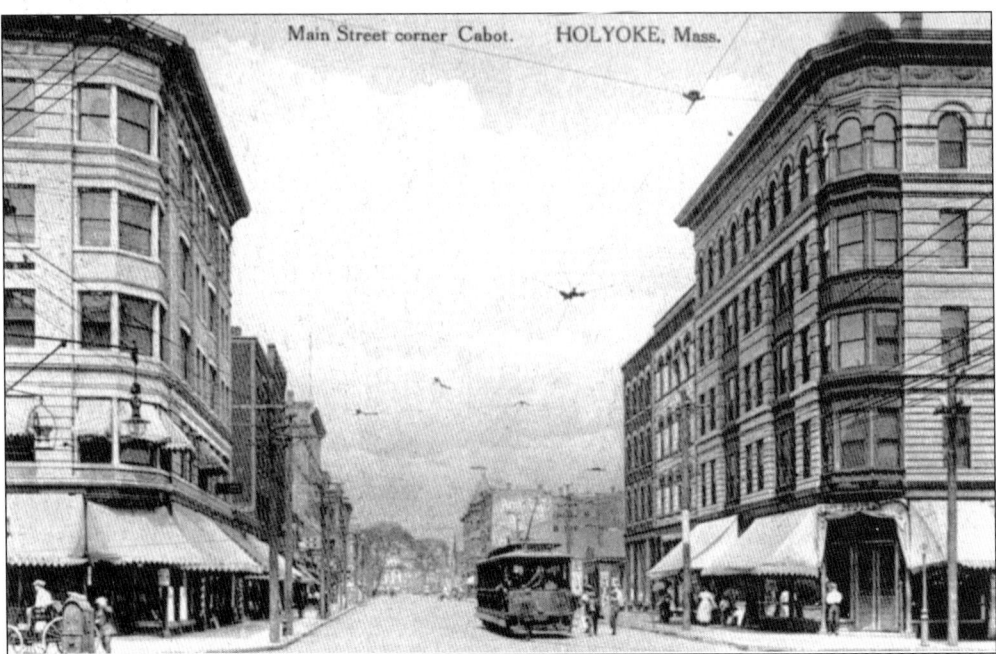

This card shows a view up Main Street that reflects its use as an industrial development. However, several of the city's better hotels were located on Main Street due to its proximity to the Boston and Main Railroad depot.

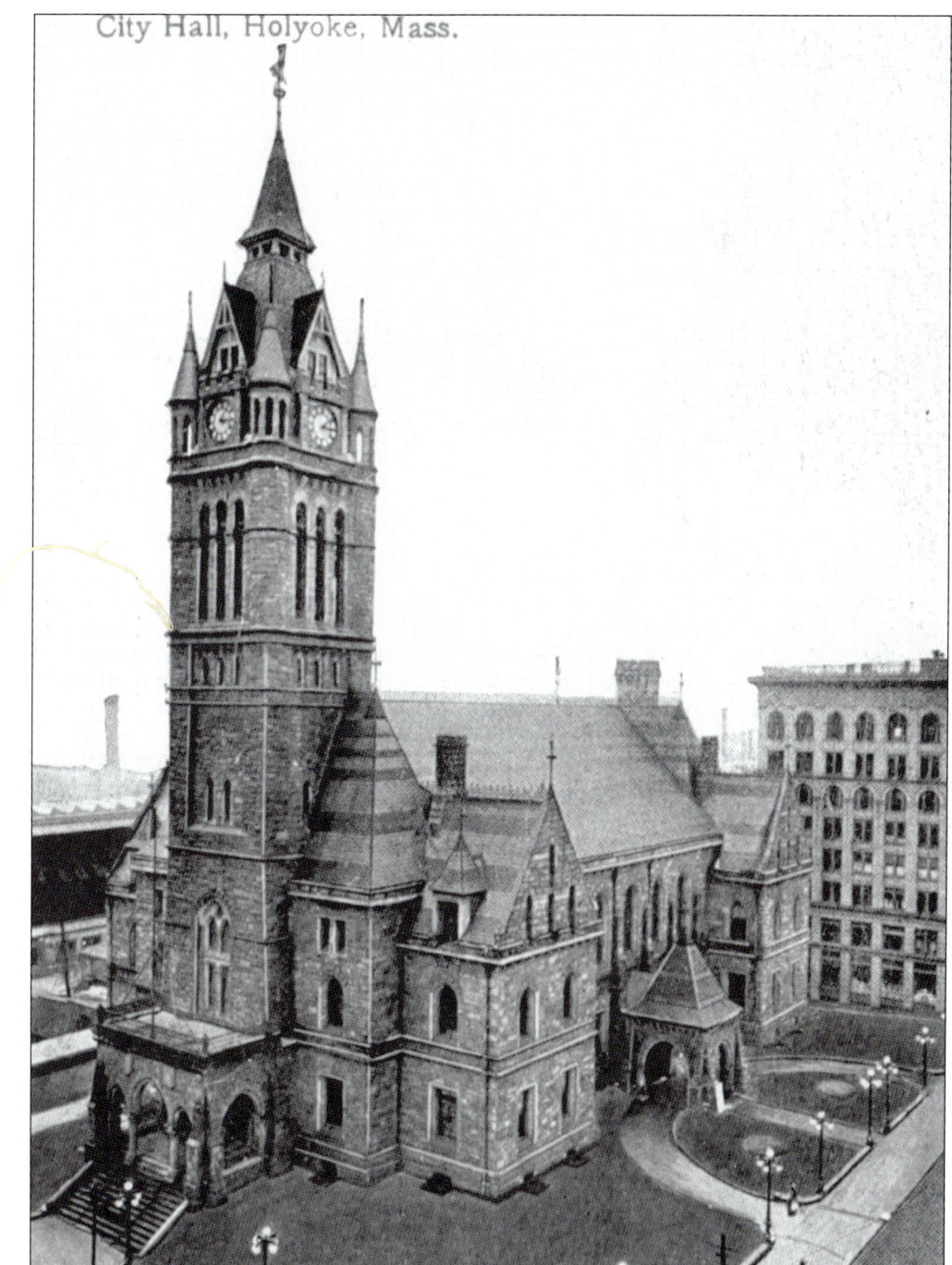

Located on Dwight and High Streets, Holyoke City Hall's 225-foot-high granite structure dominates the city skyline. Planning for the building began in 1871 with the intention that it be used as the town hall; however, by the hall's completion in 1876, Holyoke had become a city, and since then, the town hall has been know as city hall. Originally, in addition to the city offices, it housed the police department, jail, and public library. Its bell tower marks every hour and can be heard throughout the downtown section of the city.

The next four views are from city hall's tower. In this image, looking south, one can see the New York–New Haven Railroad yard and freight house. Just beyond it are the Skinner Silk mills, which burned down in 1980. The location is now the site of Heritage State Park.

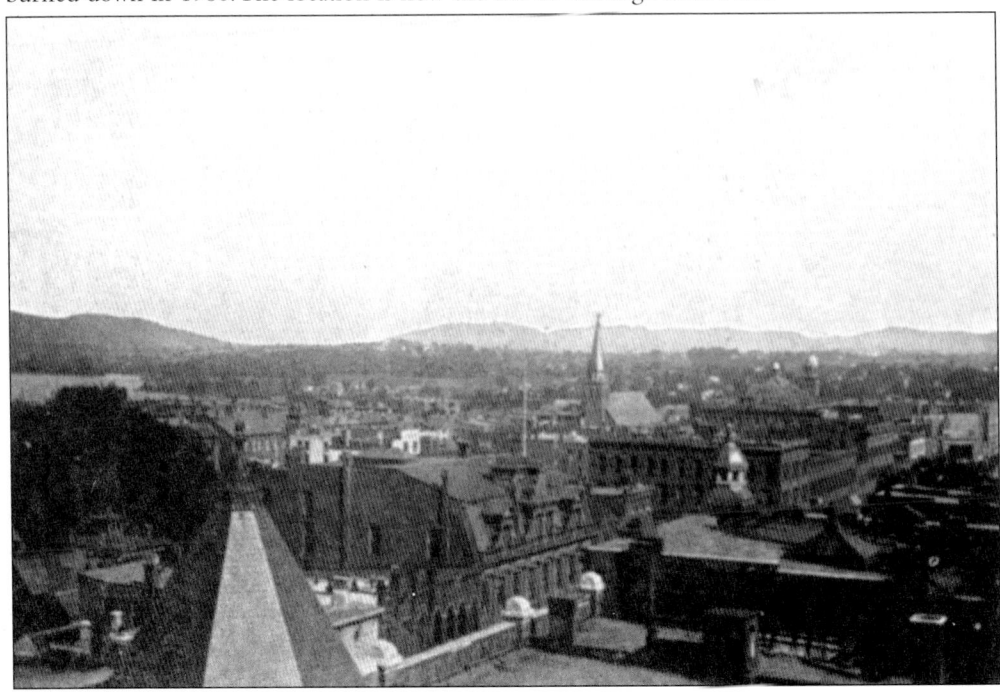

Looking north, one can see the Holyoke Range to the left and Mount Holyoke to the right. In the center is the spire of St. Jerome's Church, on Hampden Street.

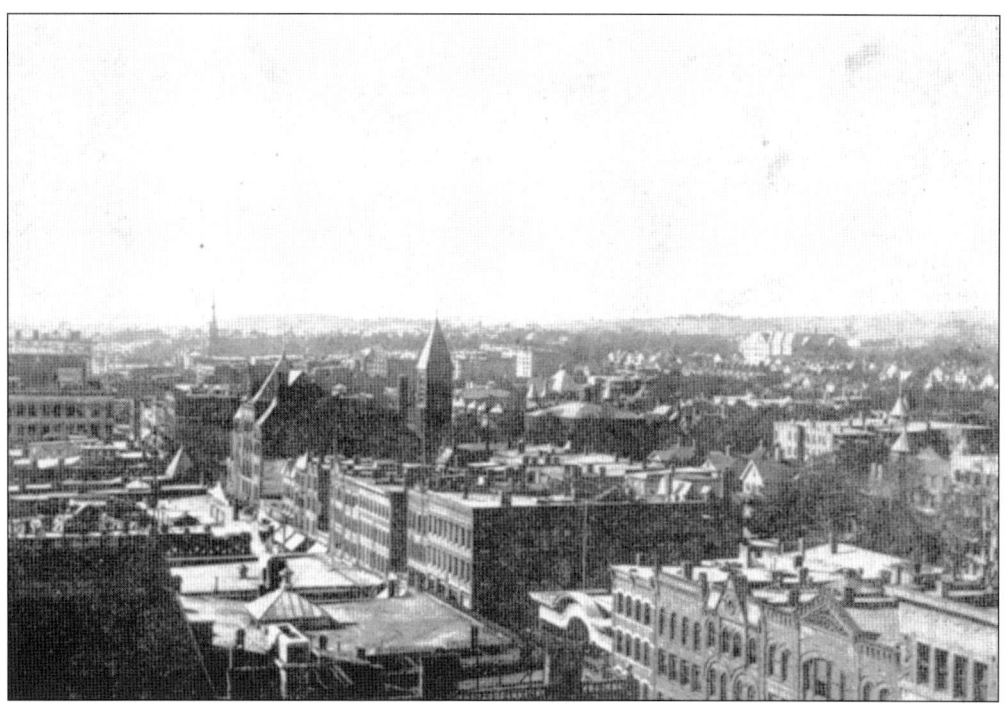

To the west, one can see High Street between Suffolk and Appleton Streets. In the center are the old YMCA building and the tower of the Second Congregational Church. In the center foreground, the arch of the Naumkeag Clothing Company is just visible.

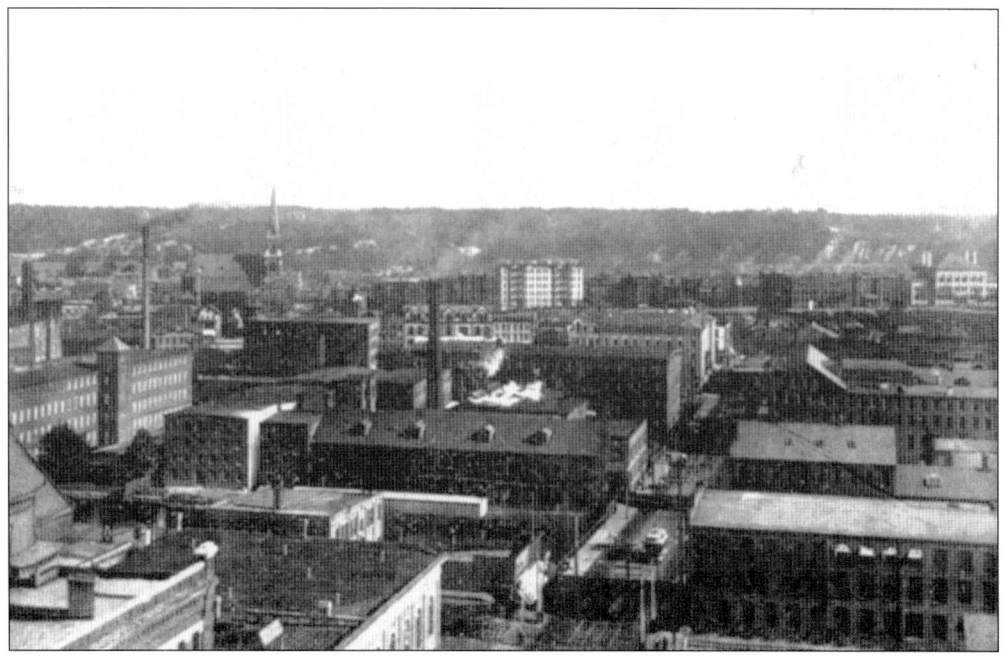

To the east, this view looks down High Street toward the Connecticut River. At the far right is the old West Street School and beyond that, across the river, is the Fairview section of Chicopee.

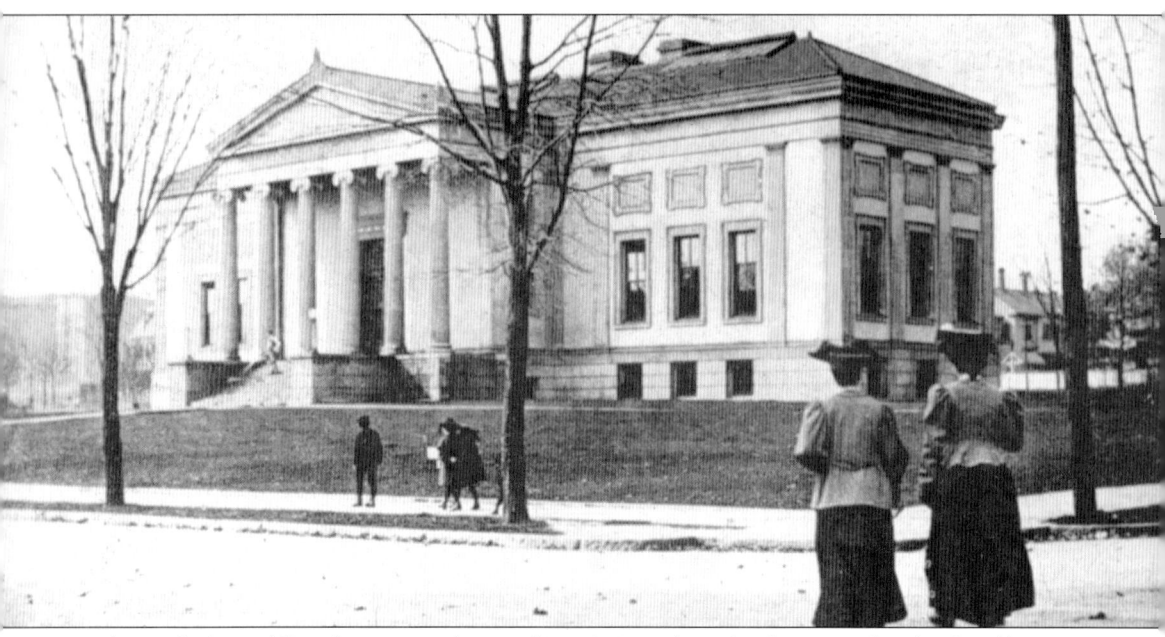

The Holyoke Public Library was chartered in 1870, and Sarah Ely was to be the first librarian. Originally operated out of a room at the Appleton Street School, it was moved to larger accommodations in city hall in 1876. The building pictured here is the library's final location. It was completed in 1902 and located on a full city block between Maple, Essex, Chestnut, and Cabot Streets on land donated by the Holyoke Water Power Company. The building is actually offset on the property due to the intention that a museum and art and science outbuildings were to be added later. The other buildings were never built, however, and instead, the museum occupied two of the second-floor wings in the library. Although Sarah Ely survived to see the building completed, she retired in 1900 and never served as its librarian. This is still the location of the Holyoke Public Library, and the building is essentially the same with no significant additions. It is also the location of the Holyoke History Room and Archives, where this book was written.

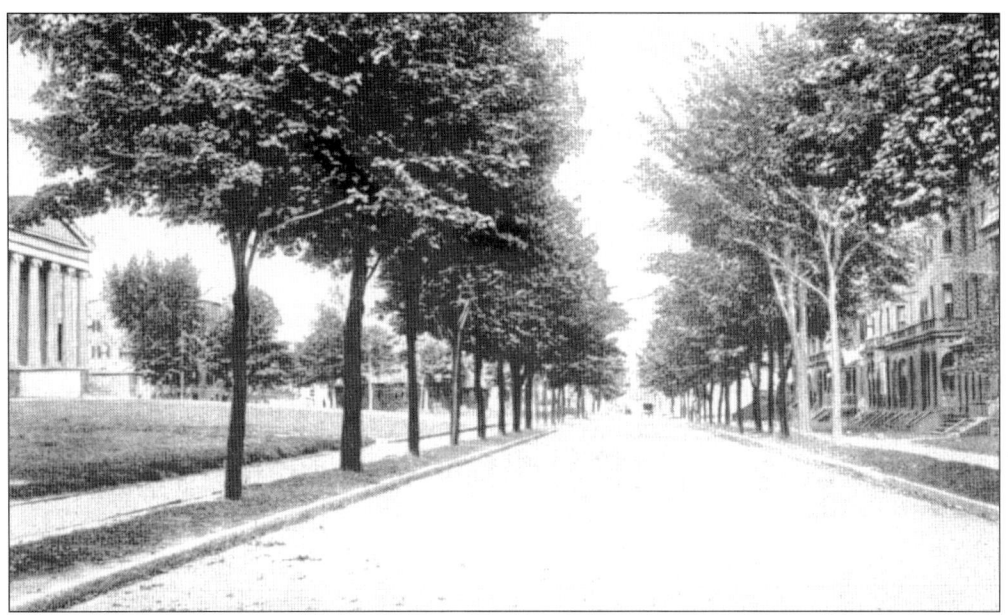

This image of Maple Street shows the Holyoke Public Library on the left and a block of brick and brownstone row houses. When Maple Street was widened in the 1950s, the curb was pushed back to the sidewalk on both sides, unfortunately loosing all of the trees and curbside grass. Other than that, the street looks much the same today with both the library and row houses still in use.

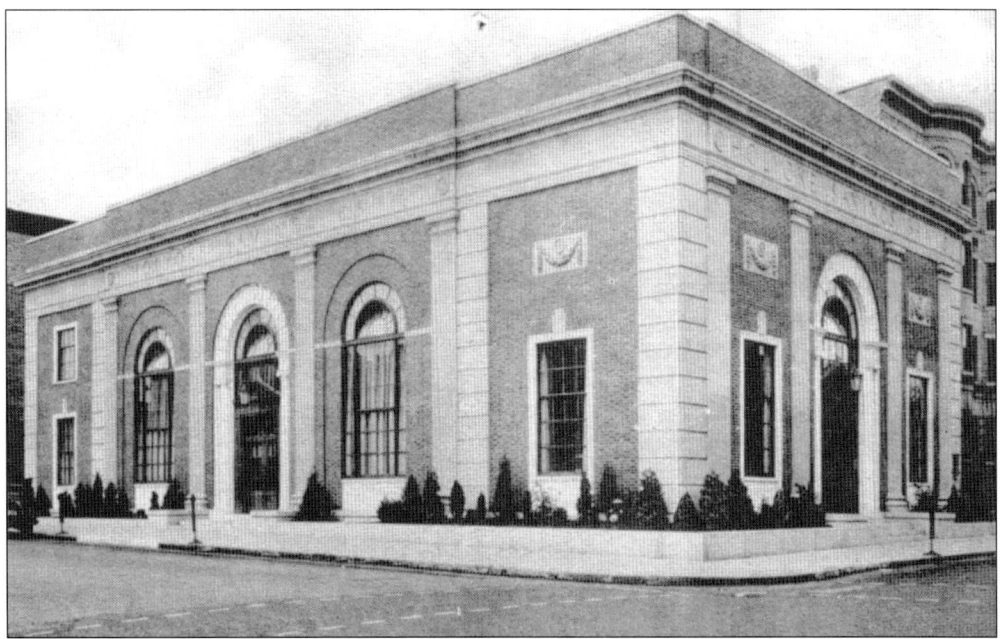

The Holyoke Savings Bank was incorporated in 1855, five years after Holyoke became a town. The bank building, pictured here, was built in 1930 and remained the Holyoke Savings Bank until it closed in 1992. It is now the main office of Holyoke Gas and Electric.

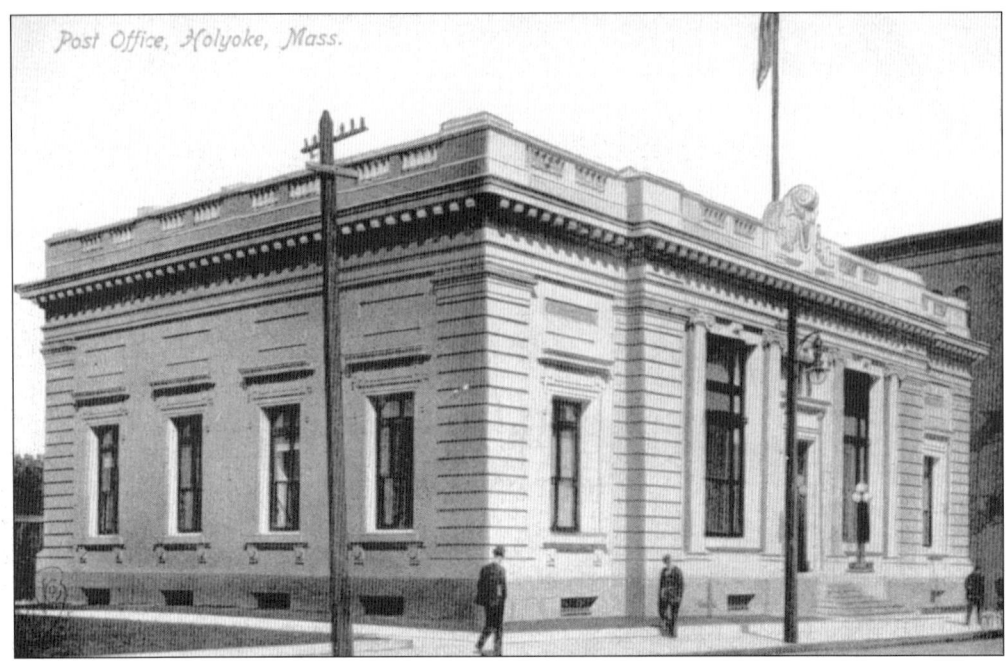

The first post office in Holyoke was at the Boston and Main Railroad station; the post office building pictured here was built in 1903 at 31 Main Street. It closed in 1935, when a new post office was constructed on Dwight Street. This building was torn down in 1942.

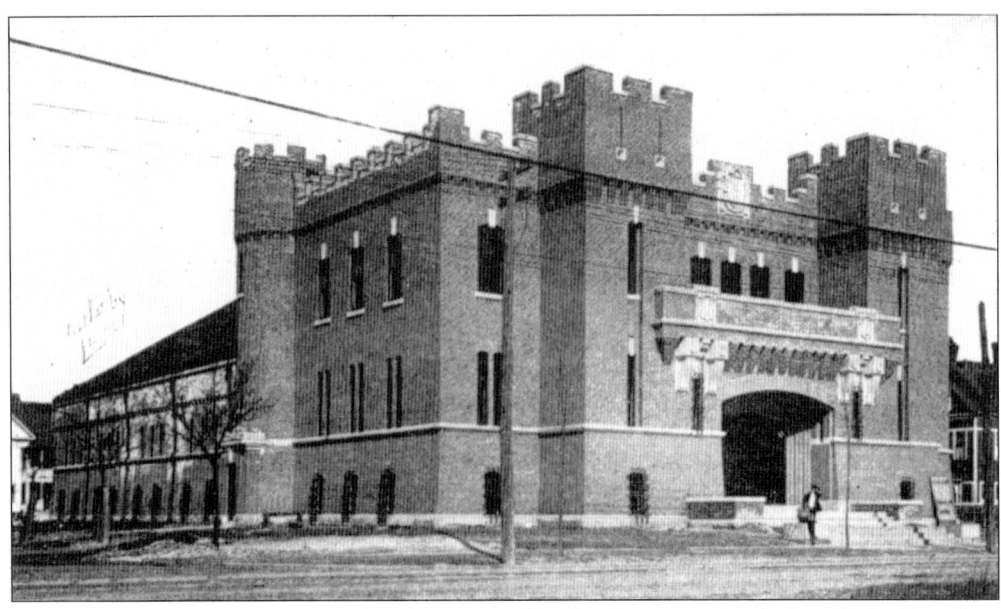

The Holyoke Armory was completed in 1907 for the Army National Guard, 1st Battalion, 104th Infantry, Company D, until it was officially closed in 1992. Although some have proposed that it be turned into a community center, the building has been left vacant. Now in disrepair, its future is uncertain.

Built in 1898, the Holyoke High School building located on Sergeant Street served as Holyoke's public high school until 1964, when it moved to a new and larger facility on Beech Street. The building was then renovated for use as the new Holyoke Community College. However, in 1968, the building was destroyed by fire shortly after it opened earlier that year.

Although the caption on the postcard lists this building as the Holyoke Vocation School, it was actually an extension of Holyoke High School. Built in 1913 directly across Sergeant Street from the high school building, it was generally referred to as the High School Annex. It closed in 1992.

Built on the undeveloped city block that was for many years called "the dudes park," the H. B. Lawrence School sits across Cabot Street from the Holyoke Public Library. Finished and dedicated in 1932, it was originally a junior high and elementary school. It was extensively renovated and rededicated in 1975 as an elementary school and continues to serve that purpose today.

The Elmwood School was built in 1893 and served Holyoke as an elementary school. It caught fire in 1908, but the building was saved and reopened later that year. It became the original location of Holyoke Community College before they moved to the old Holyoke High School building. The Elmwood School building briefly housed Holyoke Community College again after the old High School building burned down in 1968.

The cornerstone for the Highland Grammar School was placed in 1900 along with a time capsule. The building was completed in 1901. When it closed in 1990, it was the oldest school building still in use in Holyoke. The building was demolished in 1997, and the time capsule was recovered and opened.

39

The South Chestnut Street School was built in 1885 to be used as a grammar school. The building was torn down in 1971, and the land was used to create the South Chestnut Street Park.

Located on the corner of Appleton and Maple Streets, the Appleton Street School was built in 1868. Hiram B. Lawrence became the school's principal in 1872, and under his guidance, the school assembled an art collection and a teachers library by the late 1890s. By 1932, however, the students were relocated to a new location on Cabot Street. The War Memorial Building stands on the site of the old Appleton Street School today.

This is the current location of the church and school of the Lady of Perpetual Help. The building was built in 1923 and is located on Chestnut Street.

This is the original Lady of Perpetual Help Church and School building. Built in 1891, its dome can be seen in many of the views of Holyoke from the dam. The church later moved, and this building became the site of the Mater Dolorosa School.

First Congregational Church, Holyoke, Mass.

This is an image of the First Congregational Church. The Congregationalists and Baptists shared a church building until the original First Congregational Church was built in 1834 on Northampton Street. The church pictured here was built in 1888 and looks much the same today.

This card shows the Church of Our Lady of the Rosary, its rectory, and the Rosary Parish School, located on the corner of Ely and Mosher Streets. The church was built in 1887 and the rectory in 1889. Unfortunately, none of these buildings remains. The church and its associated buildings were torn down in 1976 and replaced with two-family housing.

The Second Congregational Church was founded in 1849, just before Holyoke officially became a town. As the congregation grew, a larger church was needed. The church, pictured here on the left, was built in 1885.

The Skinner Memorial Chapel can be seen directly to the right of the Second Congregational Church in the previous postcard. The construction began in 1909 but was not completed until 1912. The church was dedicated to the memory of William and Sarah Skinner. Its interior was built to resemble those of the medieval cathedrals of Europe, as can be seen in this postcard, which shows its remarkable interior.

The Sisters of Providence arrived in Holyoke in 1873 to care for the sick, orphaned, and elderly residents of the city. However, the order did not have a permanent structure for their convent until 1933, when the Mother House was built. Shown here is the entrance to the Byzantine-style chapel, which is the central portion of the structure and its grounds.

This is an image of the interior of the chapel at the Sisters of Providence Mother House. It remains essentially unchanged today.

The oldest Catholic church in the city, St. Jerome's Church, shown here on the right, was built in 1860 and stands today. Shown in the center of the postcard is the St. Jerome Institute, which was built in 1871 and served as a parochial school. Its pupils were taught by the Sisters of Providence.

This is St. Paul's Episcopal Church, which is located on Appleton and Locust Streets. Finished in 1905, it was the third church for the parish, which was originally founded in 1863 and outgrew two previous buildings.

Church of the Precious Blood, Holyoke, Mass.

The Precious Blood Church is the second oldest Catholic church in Holyoke and was founded in 1869. The oldest Catholic church, the original wooden church, was located on Cabot Street to provide Catholic French Canadian immigrants a place to worship. Due to the influx of French Canadian immigrants into the city, the church's congregation grew rapidly, and work began on a larger stone church, pictured here, only a few years later. It was completed in 1878. Unfortunately, before the new church was completed, a fire broke out in the crowded wooden church while the congregation was celebrating the feast of Corpus Christi. People became trapped in the building, and in the end, 92 people died as a result of the blaze. The Precious Blood Church persevered for the next century, but declining attendance and financial difficulties closed the church in 1990, and the building was subsequently demolished.

The Holy Cross Church is a large and dominant structure that sits between Appleton and Dwight Streets. The original parish chapel was built in 1905; however, it was found to be too small as the congregation grew rapidly. The building was enlarged in 1915, and by the early 1920s, the parish required an even larger structure. The church, pictured here, was completed in 1927 and modeled after the Ely Cathedral in England.

The Baptists are the oldest congregation in Holyoke and began work on their first church building in 1792, which was called the "Lord's Barn," in what was then known as Baptist Village. This card shows the present Elmwood Baptist Church, also known as the First Baptist Church, which was built in 1880 near the site of the original Lord's Barn and is in use today.

Completed in 1888, the Presbyterian Church of Holyoke is located on the corner of Cabot and Chestnut Streets across from the Holyoke Pubic Library on land bought from the Holyoke Water Power Company. The cornerstone of the building was laid on December 1, 1887, and the church was constructed of granite and included brownstone trimmings.

The Second Baptist Church was organized in 1849 with 42 members, most of whom had taken letters of dismissal from the First Baptist Church in order to move down to the growing settlement located closer to the Connecticut River. Their first church, built in 1855, was destroyed by fire in 1863. The church pictured here was its replacement and was built in 1865.

This is a real-photo postcard of the Immaculate Conception School. The school started in 1907 in a remodeled building on the corner of Bridge and East Dwight Streets. That building burned in 1916, and in 1917, a second school, shown here, was built.

The Church of the Sacred Heart was built in 1876 and is located on Sergeant and Maple Streets. The convent for the Sisters of St. Joseph was added in 1887, and the school was built in 1890. Although the other buildings were already completed, the 16-foot-high peaked spire was not added to the church until 1897.

Although the foundation of this church was laid at Appleton and Elm Streets in 1865, there were questions about whether or not it was the most appropriate location for the building. This resulted in work being suspended until 1869, when the building was finally completed.

This church, labeled on this card as the "Polish Church," was actually called the Mater Dolorosa Church, located on the northeast corner of Lyman and Maple Streets. Its predominantly Polish parishioners were instrumental in the construction of the church, which was completed in 1903.

Here, one can see the final parade of the Holyoke Fire Department, which occurred on October 7, 1887. The parade is shown here at its origin: the first Central Fire Station, built in 1864, on High Street. All firefighters in the city participated in the parade with their equipment. Seated in the passenger buggy at the bottom left of this image, in front of the white marble building, is Fire Chief John J. Lynch, who was the hero of the Precious Blood Church fire.

The fire at the McCauslan and Wakelin Department Store started at approximately 5:30 a.m. on December 7, 1906, right across the street from city hall. Although the Central Fire Station was located only a block away, the fire spread rapidly through the building, and Fire Chief Lynch was forced to call in all auxiliary firefighters to assist in fighting the blaze. By 7:45 a.m., fire brigades from Springfield had arrived, and the fire was ultimately contained to the two main buildings shown here. No one was killed, although the damages totaled close to $300,000.

The second Central Fire Station was built in 1915 along Maple Street, and a new station was built in 2001 at 600 High Street.

The Holyoke Fire Department's first motorized vehicle was purchased in 1901, and it was used by Fire Chief Lynch. By 1910, however, trucks like this one were used throughout the department to speed up fire-response times within the city.

53

This is a rare image of one of the early horse-drawn fire pumps. Although this one was adapted for street cleaning during the 1930s, the worn seat where the driver sat when it was drawn by a team of horses is visible.

The Sisters of Providence provided the first public health services and care for both orphans and the aged in Holyoke. This card shows the Our Lady of Providence Home for Children; however, the card's title is simplified to just the Children's Home. The orphanage they built in Holyoke was in Ingleside in 1880. Needing more space, the residents were moved to the location shown here in Brightside in 1893.

The first House of Providence was actually set up in South Hadley in 1873, but the Sisters of Providence found the Connecticut River provided too much of a boundary to their ability to help the mill-worker families who they had come to help. Pictured here is the first House of Providence in Holyoke, which was located on the corner of Dwight and Elm Streets and began assisting the sick and aged of Holyoke by 1874. In 1875, they treated the victims of the Precious Blood Church fire, and by 1876, the House of Providence was serving as the first public hospital in Holyoke.

The House of Providence Hospital was built in 1894 for the Sisters of Providence, as the need for a larger building became necessary. It was constructed on the same lot as the original House of Providence, and it became the first Catholic hospital in western Massachusetts.

In 1891, a group of prominent men met at William Whiting's home and pledged to support the construction of a city hospital. The building shown here was completed in 1893, and although it has been expanded several times, the original building can still be seen among its additions. It is now called the Holyoke Medical Center and remains the primary medical-care facility in the city.

The land for the Holyoke Home for the Aged was donated by William Loomis, and the home was built in 1911. The charitable association that financed it was made up of many of the most socially prominent families of Holyoke who were particularly concerned for the plight of elderly widows and single women, such as schoolteachers and maids. In 1968, the name was changed to the Loomis House.

This was the residence of William Loomis, who was the editor and publisher of the *Holyoke Transcript* between 1875 and 1888, when he sold it to William Dwight. A dynamic individual, Loomis also developed the Holyoke Street Railway and Mountain Park and was the founder of the Holyoke Public Library Corporation.

Crafts Tavern was a tavern and inn built by Archibald Morgan in 1785 on Northampton Street. During its long history, it served travelers stopping over in Holyoke traveling north along the Connecticut River or by coach. It did not take on the name of Crafts Tavern, however, until 1875, when it was purchased by the Crafts family. They owned it until 1923, when the title passed to the city of Holyoke.

This image shows Crafts Tavern when it was moved farther up Northampton Street in 1926. Unfortunately, although attempts were made to convert it into a historic site, it was torn down in 1951 to make room for the John J. Lynch school.

Although this home served as the Highlands Parish Rectory, its greater historical significance lies with its original owner. Located in what was originally called "Ewingville," it was built as the home for George Ewing, who was responsible for the development of the dam and the canals.

Joseph Metcalf was the treasurer and co-founder of the Farr Alpaca Mills in Holyoke. His home on Northampton Street can be seen here in the distance. The image was taken from the home of Addison Loomis Green, who married Metcalf's daughter Gertrude in 1911 and lived at a home on the adjoining property.

Kenilworth Castle, Holyoke, Mass.

Kenilworth Castle was built in 1894 as the summer home for Edward Taft and his family. The building's exterior was a replica of the Gladstone residence in England. Unfortunately, Taft died only a year after the house was completed. His family, however, lived there until 1957, when the last family member died. There was an idea proposed to make it into a museum, but the site of Wistariahurst was ultimately chosen instead. It was eventually sold to the Holyoke Water Power Company in 1959 to be used as its main office, but they determined that it was structurally unsound and of "no historical significance" and tore it down that same year.

This was the home of George W. Prentiss, who was the head of the Prentiss Wire Company. Built in 1884, it was demolished in 1957 to make way for a new street, Carol Lane.

This was the original home of William and Elizabeth Towne. Elizabeth Towne was the editor and founder of the *Nautilus Magazine,* and published it from her home. The magazine featured poems and articles regarding a spiritual movement called New Thought. The building pictured here burned in 1910, and a new brick building replaced it as the home of the *Nautilus.*

This card shows one of the homes from the rural Smith's Ferry section of Holyoke, in the very northern part of the city's limits. In many ways, Smith's Ferry is more like a small town than a district of Holyoke. In part, this is because it was annexed from Northampton in 1909. Originally called South Harbor, the community of Smith's Ferry grew because it was a crossing point for the early "swing ferries" that linked this area across the river with the Hockanum section of South Hadley. The home pictured here is located across from the Holyoke Canoe Club along Route 5.

Another example of the increase of passenger cars is motor lodges, such as this one along Route 5. The Grandview Cabins, pictured here, first opened in 1937 and were typical of the lodgings motorists could find all along Route 5, which connected Connecticut to Vermont prior to the construction of Interstate 91. In 1963, the cabins were renovated, and it was renamed the Mount Tom Motor Court.

This card shows another motor lodge located along Route 5 in the Smith's Ferry section. Riverview Cabins opened in 1933. The wording above the office reads, "Smith's Ferry River View Inn." It was renamed the Village Motor Court in 1964.

When William Skinner moved his silk mill from Williamsburg to Holyoke in 1874, he brought his home with him as well as his belongings. Originally built c. 1848 in the part of Williamsburg called "Skinnerville," it was disassembled and brought by oxen to Northampton and then floated down the Connecticut River to Holyoke. It was then reassembled on grounds covering an

entire city block bordered by Beech, Cabot, Pine, and Hampshire Streets. The home was named Wistariahurst after the wisteria vines that cover most of its southern and eastern sides, as can be seen in this image. The family donated the mansion to the city in 1959, and it is now the Wistariahurst Museum.

This card shows the marble lions that were bought in Rome by the Skinners in the 1880s and then shipped to Holyoke. They are now located at the Cabot Street entrance to the museum.

The grounds of Wistariahurst were spectacular. At various times, landscape architects were employed to work on different elements of the grounds, and as many as three gardeners were required to maintain them.

Three

RECREATION AND SOCIAL SOCIETIES

The Soldiers Monument is the centerpiece of Hampden Park, now called Veteran's Park. The monument was dedicated on July 4, 1872, to honor and remember the Holyoke soldiers that died during the Civil War. Although the monument is dedicated to Union veterans, the design, chosen by a committee, was proposed by H. G. Ellicott, who had fought for the South in the Confederate cavalry.

The location of Hampden Park was part of the original layout of the city and was to be called Hampden Square. It was not until 1861, however, that the Holyoke Water Power Company donated the land to the city for the creation of the park. The cannon in the foreground was melted down during World War II.

Mackenzie Field is dedicated to the memory of John S. Mackenzie, who was awarded the Congressional Medal of Honor in 1917 during World War I. Although it is now part of the Holyoke High School, the field was used for many years by minor-league baseball teams and for various baseball tournaments.

Located at the intersection of Park and South Bridge Streets, Germania Park was established in 1883 primarily for the German immigrants who worked at the Germania Mills and lived in the area. Between the trees on the right, one of the blockhouses where many of the German residents lived is visible. The Lutheran church and school were located across the street from the park.

The wading pool pictured here was called Riverside Park not because it was near the Connecticut River but because the property was, originally, the location of Joseph Prew's Riverside Racing Track. In 1905, the city took over the property, and the track was removed. After the area was renovated, it was renamed Springdale Park.

The Holyoke Water Power Company donated land in 1883 for this park, which was designed by Frederick Law Olmsted and named Kerry Park. In 1885, it was renamed Prospect Park for its view of the Connecticut River and the Holyoke Dam. This area of Holyoke became a predominately Polish community in 1939, and the park was renamed again as Pulaski Park for Gen. Count Casimir Pulaski, the Polish hero who fought for the Colonies in the American Revolution.

The Elmwood section of Holyoke was once cut off from the downtown areas by a dingle that ran from the Yankee Peddler Inn toward the Connecticut River. Elmwood Park was created along a stream, which was called Dry Brook by early settlers of the region.

The Mount Tom Golf Club was originally organized in 1898 with 30 members. This image shows the larger clubhouse, which was built in 1911, when the membership increased to 165. In 1969, the name was changed to the Wyckoff Country Club, and the course is used by members today.

The original Holyoke Canoe Club was incorporated in 1888 and consisted of a boathouse just above the dam. As the club expanded, it moved several times until the fourth clubhouse was built in Smith's Ferry in 1903. Its facilities are enjoyed by members today.

This 1913 card shows the Children's Day celebration at the Holyoke Canoe Club. This image also provides a better view of the canoe club's grounds.

Located in the Smith's Ferry section of Holyoke, the Holyoke County Club was converted from cattle-grazing pastures to a membership-based recreational facility in 1906. This card shows the original clubhouse and tennis court.

Golfing was another pastime enjoyed by members of the Holyoke Country Club. As seen in this image, the club grounds were quite extensive.

This is the golf course of the original Mount Tom Golf Club. A new course was built in 1922, and when Interstate 91 was built during the 1960s, its path ran straight through the course. A new course was purchased and became the golf course of the Wyckoff Country Club.

In 1871, members of Holyoke's German population organized a gymnastic society called Turnvereins. The hall was built in 1876 and expanded to include the structure and grounds seen here from 1902. The facility was known for its open-air gymnasium and indoor exercise facilities.

In 1898, the Alsace Lorraine Society purchased the property at 249 Park Street and remodeled the existing building into their Union Hall, which is pictured here. Beginning in the 1940s, it became the home for other social and athletic clubs, but by 1980, the building was gone.

The Holyoke Club was founded in 1902 to create a social club where membership was based on an individuals intrinsic worth and not their wealth, nationality, or political beliefs. The members chose for their meetinghouse the former residence of Joseph Parsons (president of Parsons Paper Company), which is located on the corner of Suffolk and Chestnut Streets. Today, the building stands, and it is the home of the Holyoke Day Nursery.

Founded in 1904, the Holyoke Elks Lodge has enjoyed a century-old place in the city of Holyoke. Their first lodge was purchased in 1908 at the corner of Maple and Essex Streets. The building pictured here was built in 1913 and was located at 317 Maple Street.

The Holyoke chapter of the Knights of Columbus, Council 90, built these headquarters in 1894 at 78 Suffolk Street. Unfortunately, just after completing extensive renovations to the building, it was destroyed in a fire.

Y. M. C. A. Holyoke, Mass.

The Holyoke YMCA on High and Appleton Streets was completed in 1891. William J. Morgan became the physical director in 1894 and is credited with inventing the game of volleyball. It has also been argued that basketball was created here and only later developed by James A. Naismith at the YMCA in Springfield. However, Morgan and Naismith were good friends, and during his lifetime, Morgan had no interest in the claims that he was basketball's true founder. Any records that may have supported or disproved this claim were lost when the building was destroyed by fire in 1943.

When this building on Maple Street was built it was know as the Franklin Hotel. The Young Women's Christian Association (YWCA) purchased the building in 1910, which remained the location of the YWCA until 1975, when they merged with the Holyoke Girls Club on Bond Street. Sadly, the building was torn down shortly after to create a parking lot.

The Mount Tom Masonic Lodge was founded in 1850, the same year as the incorporation of Holyoke. Many of the most influential citizens of Holyoke were members of the lodge, which enjoyed great prominence in the city. The lodge occupied several different locations on High Street before the permanent Masonic temple, pictured here, was built in 1921 on Chestnut Street behind the Holyoke Public Library.

This is a 1916 portrait postcard of Holyoke boxer Charles Dellapenna, who boxed under the name of "Chick West." He fought between 1910 and 1921 and became the welterweight champion of New England in 1919. In 141 bouts, he never cancelled a match, was never knocked out, and won 136 of them. He began having eye trouble in 1919 and was blind in one eye by 1920. He continued to fight the following year, but his career ended prematurely when an operation that was supposed to restore his eyesight met with complications, resulting in the loss of sight in both of his eyes. Later in life, he and his guide dog, Jing, advocated for state and national programs to assist disabled athletes, and he even competed one last time in an exhibition fight at the age of 53. It is reported that very few people even realized that he was blind during the match and that his opponent asked him "to take it easy, those body punches don't feel too good."

Coming Champions--Holyoke, 1909

Top Row Files p Crutcher p Ruell c f Duggan 1 b Ahearn c Dolan r f Syfert p McCabe p
Lower Row Baker 2 b Sindler p Burke l f Beaumont c McCormack s s Perkins 3 b

HALL & LYON CO.

Although the Holyoke Papermakers baseball team finished second in the Connecticut League, they did not win the Connecticut League championship in 1909. However, Perkins, seated in the lower right-hand corner of the image, did lead the league in batting that year.

Mrs. Metcalf is shown here in her Daughters of the American Revolution costume. This photograph was probably taken at Holyoke's 50th anniversary celebration near Craft's Tavern on Anniversary Hill.

This is an advertisement card for the Guy Hobbs dog show. This card features a picture of Guy Hobbs and a few of his canine performers. The dog show operated from the late 1890s to the early 1900s.

This card from the Guy Hobbs Dog Show illustrates the effect his early experience working in both his father's and grandfather's livery stable had on the show. He was the grandson of Sewell J. Hobbs, who opened a livery stable in Holyoke in 1878.

Connecticut River, Holyoke, Mass.

This is a turn-of-the-century view of the Connecticut River. Prospect Park, as it would have been called when the image was taken, can be seen in the center of the card on the right shoreline. Farther to the right one can see the Holyoke sawmill that processed the lumber brought down during the log drives.

On May 5, 1917, an event called the Exercises of the Holyoke Public Library at the Raising of the Flag was held on library grounds. The picture shows the area in front of the library where the podium was set up for various speakers, which included the mayor, the president of the board of aldermen, and other community leaders.

Four

MOUNTAIN PARK AND MOUNT TOM

Mt. Park and Mt. Tom, Holyoke, Mass.

This card presents a good view of the relationship between Mountain Park, located in the foreground, and the Mount Tom Summit House, seen in the upper right-hand corner of the image. Mountain Park was created in 1895 by the Holyoke Street Railway Company to generate extra fares and to provide work-weary residents a place to relax at the end of the trolley line.

This rural scene, which includes Mount Tom in the distance, shows what life in Holyoke was like before the canals were built. Holyoke's early history was that of a quiet farming community. It was not until the late 1840s, when the dam and canal work had begun, that it forever changed into an industrial center.

Here is a closer look at the Rustic Arch located in the center of the Mountain Park complex.

When the Holyoke Street Railway began providing service to Mount Tom, it greatly increased its accessibility to the citizens of Holyoke and people from the surrounding communities. This picture shows trolleys arriving at the Mount Tom station, located near the Rustic Arch. The hill in the background was called "Little Mount Tom," and if one looks carefully, one can see an observation tower located at its summit.

Here is Mountain Park's theater, which was called "the Casino." It opened in 1895 using an open stage, and by 1901, the large enclosed building, seen here, was completed. During the 1950s, Hal Holbrook performed there with the Valley Players. The last performance on the theater's stage was in 1965, and it was taken down shortly thereafter.

A 22104 Dancing Pavilion, Holyoke, Mass.

This card shows the ballroom, or "Dancing Pavilion," as it is called here. Beside it and to the right is part of a water ride that was a feature of the early days of Mountain Park. Although light and faded, this image shows the Mount Tom Summit House along the skyline in the background.

Holyoke, Mass.
Lily Pond Mountain Park

The lily pond was another example of the relaxing environment Mount Tom provided. Located near the Rustic Arch, it was a favorite spot for people to enjoy a summer day.

Another diversion offered by Mountain Park was relaxation. The children in this card can be seen enjoying a beautiful day overlooking the parkland.

Besides relaxation, visitors to Mountain Park enjoyed a number of outdoor leisure activities. Here a group is enjoying a game of beanbag toss.

Deer Park, Mountain Park, Holyoke, Mass.

Many of the deer around Mountain Park became tame after being fed on a regular basis by visitors. The Deer Park was an early attraction of the park where the deer congregated in expectation of snacks provided by people wanting a closer look at them.

4823 RESTAURANT BUILDING, MOUNTAIN PARK, HOLYOKE, MASS.

The Mountain Park Restaurant was built in 1909 at the same time as the dance pavilion. Visitors were offered a steak or chicken dinner with soup and a dessert of ice cream topped with pineapple and mint sauce for $2. The restaurant burned down in 1971, along with the dance pavilion.

Merry-Go-Round, Mountain Park,
Holyoke, Mass.

This card shows the original merry-go-round that was built at Mountain Park shortly after it opened. The carousel for which Holyoke is known, however, was not built until 1929 by the Philadelphia Toboggan Company and consists of 48 hand-carved horses. The carousel remained a favorite attraction until Mountain Park closed in 1987. Afterward, John Hickey began a "save the carousel" project, and the fund drive received donations from all over the Pioneer Valley. In the end, the carousel was saved and reopened in 1993 in a new building located at Heritage State Park.

BEAR DEN, MOUNTAIN PARK, HOLYOKE, MASS.

The Bear Den and nearby Deer Park were attractive sections of Mountain Park, which was not intended to be a full-scale zoo. The attractions allowed visitors to see examples of wildlife that used to roam freely in the region. Bears still live in the protected wilderness areas around Mount Tom.

Rustic Pavilion on Mt. Tom. Holyoke, Mass.

The rustic pavilion was built in a similar fashion to the Rustic Arch. Located on the southern side of Mount Tom looking back toward the city, it provided visitors with a splendid view of the valley below.

The addition of the Holyoke Street Railway line made traveling to the Summit House much easier. In the foreground is the Mountain Park station, and in the distance, the Summit House Station can be seen. This card also provides an excellent view of the steep grade that separated the Summit House from Mountain Park.

Here is a better view of Summit House Station, as seen from the Summit House itself. The valley seen below is on the western side of Mount Tom and shows the town of Easthampton. The walkway led directly to the Summit House.

91

Easthampton, from Mt. Tom, Holyoke, Mass.

This view is farther along the walkway and on the Summit House platform. It provides a better view of the downtown section of Easthampton than the previous image.

The Ragged Cliffs of Mt. Tom. Holyoke, Mass.

The Ragged Cliffs Overlook on Mount Tom provides sweeping views of the Berkshire Hills to the west and the Pelham Hills to the east. This area is located just below the Summit House.

SUMMIT HOUSE, MT. TOM.

This illustrated postcard shows the first Summit House, which was built in 1897. Located at an elevation of 1,202 feet, it provided a spectacular view for the visitors who came from all over the valley. Unfortunately, it caught fire and was destroyed only a few years later in 1900.

G 22124 Mt. Tom Summit House, Holyoke, Mass
This is a summer resort. Isabel

The second Summit House was completed by 1901. Larger than the original, it also possessed the distinctive domed top that is seen in most images of Mount Tom. This structure continued the success of the original and lasted until 1929, when it was destroyed by a fire. A third Summit House was built, but it closed in 1937 and was torn down in 1938.

Pres. William McKinley had a niece who attended Mount Holyoke College in South Hadley. When he and the First Lady attended their niece's graduation, they made a side trip to visit the Summit House on June 19, 1899. The large man to the left was reportedly President McKinley's chief of security.

Although less well known than the Mount Tom Summit House, the Eyre House, built on the summit of nearby Mount Nonotuck, was the first of such attractions in Holyoke. First erected in 1851, it unfortunately caught fire and burned just after the construction of several new buildings in 1901. Its owner, William Street, was unable to secure the funds needed to rebuild it.

Five

Trolleys and Other Transportation

Bounded by Mosher, Bowers, and Lyman Streets, the Boston and Maine Railroad station was designed by the noted American architect Henry Hobson Richardson and was constructed of granite with dark brownstone trim. It served as the destination of travelers and immigrants to Holyoke from 1885 until it closed in 1966. Although no longer in use and in disrepair, the building still stands.

Transportation across the Connecticut River was difficult before the bridges were built. This card shows a "swing ferry" that operated between the Hockanum section of South Hadley and the Smith's Ferry section of Holyoke. This image was taken on the Smith's Ferry side and is looking toward Mount Holyoke in South Hadley. At the time this card was created, however, Smith's Ferry was still part of Northampton. It was annexed by Holyoke in 1909, and that is why it is listed as Northampton on the card.

This image shows the ferry heading toward Hockanum with passengers aboard. The Mount Tom Summit House can be seen in the distance along the skyline.

The autobus, shown here, was typical of early public transportation endeavors in Holyoke at the beginning of the 20th century. Buses such as these were popular for trips to destinations outside of the city, but within the city, the Holyoke Street Railway remained the primary means of transportation during this period.

These are the bridges that connect Holyoke with Willimansett. The railroad bridge on the left was constructed by the Boston and Main Railroad in 1845 to provide railroad access to Holyoke. The pedestrian and road bridge to the right was not built until 1893. Both bridges are still in use.

G 2:113 Holyoke and South Hadley Bridge, Holyoke Mass.

Bridges made a huge difference to commerce and travel in Holyoke. The Holyoke–South Hadley Bridge, built just south of the dam in 1872, was the first bridge used by private vehicles to cross the Connecticut River in Holyoke. It remained unchanged until it was expanded in 1890.

Holyoke Bridge over Connecticut River, Holyoke, Mass.

This card shows the expanded Holyoke–South Hadley Bridge. The expansion widened it by 18 feet and accommodated both trolleys and two-way vehicle traffic. It survived many floods and served both communities until it was closed in 1994, when the new Veteran's Memorial Bridge was completed. The old Holyoke–South Hadley Bridge was torn down the following year.

The horse-drawn streetcar made its debut in Holyoke in 1884. Although the barn and stable was across the Connecticut River in South Hadley, there were originally five horses dedicated to operating the two cars that served the two miles of track in Holyoke. At the peak of its operation, there were more than 80 horses dedicated to pulling streetcars in the city. The caption on the back of the card indicates that the operator was a John Haskins who lived at 93 Bowers Street.

This real-photo postcard shows the teams being harnessed to the cars at the stables in South Hadley. Passengers are already on board and waiting for their trip to Holyoke. This image was likely taken in the spring or early summer; the car in the foreground is an enclosed car, but the one just back from it is an open summer car that would not be used in colder weather.

Here is a better look at one of the open summer cars. This card also shows the transition to electric power from horse-drawn cars that were used until 1891. By this time the route covered almost 7 miles of track. At its peak during the 1920s, the railway extended into Springfield, Westfield, and Northampton with almost 73 miles of track.

With so many miles of track, the railway was always in need of repair at some location. Here, a horse-drawn repair vehicle is seen working on the overhead trolley wires. Wagons continued to be used to service the trolley lines until gasoline-powered trucks replaced them.

Here is the portion of the railway that transported visitors between Mountain Park and Mount Tom's Summit House. Shown here is the switch where the uphill bound car and the one headed back to Mountain Park could pass each other at the midway point between the Mount Tom and Mountain Park Stations.

101

Two cars operated on the on the eastern slope of Summit House: the Elizur Holyoke and the Rowland Thomas. The Elizur Holyoke car was named after the city's namesake, and the Rowland Thomas was named after the explorer who gave Mount Tom its name. Both men were early settlers of the region and led expeditions along the Connecticut River.

This card shows the Elizur Holyoke's sister car, the Rowland Thomas, on its way toward the Summit House. Built in 1897, the two cars were counterbalanced and traveled along a mile-long track to and from the Summit House. Before the line ended in 1936, the cars experienced only one accident.

This card shows the trolley route between Holyoke and Westfield. Although it was scenic in good weather, it was sometimes difficult to keep the tracks clear during the snowbound winter months.

The car barn was where trolleys were repaired and serviced. This image shows a group of trolley operators and mechanics at the car barn standing in front of the variety of special-event signs that were mounted on the trolleys.

During the blizzard of 1905, all transportation in an out of the city was shut down. In places along the Holyoke-Westfield trolley line, the snowdrifts were more than 10 feet high. Four trolley cars were lost in snow banks after they had become stuck. Fortunately, no one was hurt, and by mobilizing crews of shovel teams and trolley plows, service was restored the following day. This image was taken several days later when the tracks were fully cleared.

Here are the open-topped summer cars used by the Holyoke Street Railway. One of them is bound for a baseball game between Holyoke and a team from New Britain, Connecticut.

Safety for passengers and pedestrians was always of great concern to the Holyoke Street Railway Company. Here, a dummy is used to demonstrate an "eclipse fender," which was a safety device used to prevent fallen pedestrians from being run over by the trolleys.

Pictured here is Car No. 105 stopped on Main Street, waiting to collect fares for a ride up to Mountain Park. The cars generally had a staff of two: a conductor to collect fares and a motorman to operate the car.

This real-photo postcard shows four operators posing for a picture in front of an enclosed winter car. The first two on the left are unknown; the other two are Milton McIntyre (left) and Ed O'Donnell (right).

Of all the cars in Holyoke's trolley system, Car No. 110 was unique. Nicknamed "the jinx" car, it had its first recorded accident in 1917, shown here. It jumped the tracks and collided with a four-story apartment block, causing the building's facade to collapse and sending a piano from the fourth floor down upon Car No. 110's roof. If one looks closely at the image, one can see the piano just above the roofline. Other accidents occurred. In 1926, it jumped the track on the Pelham Street bridge and went nose first into the river. In 1933, it was hit by a beer truck and knocked 40 feet off the rails. And in 1934, it was involved in a head-on collision with an automobile. Interestingly, when the trolley system ended in 1937, Car No. 110 was the last to be burned at Mountain Park.

Although water power provided Holyoke with a canal system that turned it into an industrial center, such a close proximity to the water had its disadvantages too. An elevated sweeper car with its brushes removed, shown here, was used to ferry passengers during high water on the Springfield-Holyoke line during the 1902 flood.

Here is a sweeper car that was used to clean the tracks around the city. Many similar cars were used to maintain the rail lines.

This is another kind of work car. This car is used for stringing the overhead electrical cables used by the railway. The enclosed car has a ladder on its side and a platform that can be seen on its roof. The platform contained a seat that elevated so a workman could attach the cable to the overhead lines. Behind the elevator car is a trailer that holds the spools of wire.

Although the trolleys could be used to lay out the cable, repairs were easier to make using wagons, during the early periods of the railway, or trucks, as pictured here. These vehicles had the advantage of not being restricted to the rail lines. Looking closely, one can see that this early truck has spoked wheels with hard rubber treads instead of inflatable tires.

109

Here is another type of railway maintenance vehicle, the trolley plow. This trolley, pictured here operating on Main and Dwight Streets in 1936, was equipped with a large metal plow to remove snow and keep the tracks clear. After snowstorms, many residents waited at home until the plow went by before driving their cars on the city streets.

Here is a good view of the inside of the car barn that housed the trolleys. This is the maintenance area, and the grease pit where mechanics serviced the underside of the cars can be seen in the foreground.

Jitneys were automobiles used by freelance operators trying to compete with the trolley lines. The jitney pictured here offered service to anywhere in Holyoke and its surrounding communities, as well as up the steep grade to Mountain Park. Although they had fewer seats than the trolleys, the jitneys could go down any street. Their services continued to plague the trolley lines until 1915, when they were banned from operating on municipal streets.

The Holyoke Street Railway began to purchase its first buses in the early 1920s to supplement its trolley service. Pictured here is Bus No. 4, which was one of the first put into operation in Holyoke.

Here are a few of the buses being repaired in the Holyoke Street Railway Car Barn. If one looks closely, one can see the tracks in the floor and the overhead wiring used by the trolleys, which the buses were beginning to replace.

This real-photo postcard, taken in 1936, shows the "halfway line," where trolley service ended and passengers needed a bus transfer to continue to their destination. This kind of dual operation lasted only a few years before the trolleys became too expensive to maintain and their service was halted.

This may look like another halfway line, but this passenger transfer is actually due to debris covering the tracks just beyond the view of the card. This scene occurred in 1936, just after a violent windstorm. Such instances were further reasons why buses were eventually chosen to replace the trolley cars entirely.

113

Another problem the trolleys had to contend with was the increasing number of passenger cars used throughout the city. Unable to share the same roads in the manner that buses could, the old railway cars operating on city streets were utilized less and less as bus service increased.

In 1937, the bus system finally replaced the trolleys. This image shows the tracks being pulled up. This process sped up when the United States entered World War II and there was a general need for scrap metal. What sections of track were not pulled up during this period were eventually paved over.

Although buses were more economical for the Holyoke Street Railway Company, they brought their own share of hazards. On January 15, 1938, at 5:30 a.m., a bus hit a patch of ice after it turned from Race Street onto Dwight Street. The driver lost control of the bus and crashed through the bridge railing over the second-level canal. The bus came to a stop just before entering the freezing water, and the driver and his fortunately empty bus received no injuries. Later that day, a crane was needed to lift the bus back onto the street, and from there, it was able to return to the car barn under its own power.

When the Holyoke Street Railway Company decided to scrap its trolley system and all maintenance equipment, they employed wrecking crews to dismantle many of the cars. Pictured here is car F-4, which was reportedly the last one to operate on the rail system. To the left is one of the wrecking crews; to the right is a man named John Williams, who was the last trolley passenger

and the first bus passenger on the line. In his right hand, it looks like he is holding a cigarette, but it is in fact a piece of chalk that he used to write "THE END" and "John B. Williams End" on the car behind him.

Here is one of the wrecking crews that stripped out the interiors of a series of trolley cars in the area around Mountain Park. All of the cars were stripped of anything of value before they were destroyed.

Retirement was not kind to the trolley cars. Here are two that have been completely stripped and wrecked. These particular cars were then burned at the cove by the present Mueller Bridge. One can see some of the water from the cove in the background.

These two images show the eventual fate of the trolley cars. The area around Mountain Park was where most of the cars were eventually destroyed. They were burned to simplify the process of separating the salvageable metal from the rest of the vehicle. As the fires died down, the burnt cars were pushed down along the tracks and more cars were then rolled along the line to take their place. Eventually, almost all of the cars were destroyed in this manner.

Not all of the cars were destroyed, however. A few survived to be used for other purposes. This card shows how four of the winter cars were converted to summer cabins by the simple addition of an outhouse. These cabins were located at Lake Metacomet near Belchertown for many years.

The trolley cars pictured here remained in Holyoke as inexpensive additions to the Miss Holyoke Diner, which was located on North Bridge and Canal Streets. They used several cars to expand the original diner, but in 1946, the cars were removed when the owners built a larger restaurant building on the site.

Six
Hurricane and Floods

This real-photo postcard shows the 1934 flood and was taken just below the Holyoke Dam on the South Hadley side. The image shows how powerful the floodwaters along the Connecticut River can be.

This early-20th-century postcard shows an ice dam along the Connecticut River. This area frequently flooded when water built up behind masses of ice that broke apart suddenly, releasing flood levels of water into riverside communities like Holyoke. The people in the foreground are almost certainly added via artistic license, since few people would venture out onto one of these ice dams without a very good reason.

In 1913, the water at the Holyoke Dam had reached its highest level since it was built. Although minor compared to later floods that occurred in the 1920s and 1930s, the flood filled the basements and lower levels of many mills, forcing them to close.

This image shows a trolley passing over the Holyoke–South Hadley Bridge during the flood of 1913. Despite rising floodwaters, the trolley service continued, with only a few of the downtown routes along the canals closed.

Here is an example of the kind of damage floods caused. During the 1927 flood, this section of the Holyoke and Westfield Railroad collapsed when the ground beneath the tracks was undercut, causing the cars to topple into the rising water.

This image shows the floodwaters at the dam during the 1934 flood. Although not as damaging as some of the other floods, it shut down streets, mills, and businesses in the flats and downtown sections of the city. There was even a body spotted passing over the dam that was never recovered.

In 1936, another flood hit the Connecticut River Valley. Taken from above the gatehouse at the mouth of the Holyoke Canal System, one can see the swell in the water between Holyoke's stone dam, built in 1900, and the old wooden dam, which was located 170 feet behind it.

This is a view from the South Hadley side of the Holyoke Dam during the 1936 flood. Work crews are busy filling sand bags in an effort to prevent the water from overflowing at the South Hadley side of the dam, where water was beginning to flood the area of South Hadley Falls.

This is an image of the railroad bridge between Holyoke and Williamsett during the 1936 flood. The floodwaters have almost completely submerged the stone pylons that supported the bridge.

In 1936, it was difficult to do much to prevent the floodwaters from reaching the flats section of Holyoke. Here is a postcard showing Main Street between Jackson and South Streets under approximately eight feet of water. The Holyoke Envelope building is on the right and the Sheldon Transfer Company is on the left.

The 1930s was a hard decade for Holyoke. As if the Great Depression and several floods were not bad enough, a hurricane struck in 1938, leaving damage from not only high winds but also another flood. The following images were taken the day after the hurricane struck. The image above shows floodwaters still surging around the dam.

Here is the Holyoke–South Hadley Bridge after the hurricane and flood of 1938. The hurricane originally was traveling toward the Florida Keys but suddenly changed course and hit New Jersey on September 21, 1938. It hit New York shortly afterward, and within a few hours, it had engulfed the Connecticut River Valley.

The home pictured here suffered only minor damage and a fallen tree in its yard. Many places throughout the rest of Holyoke were not so lucky. Schools were so heavily damaged that they were closed for many days afterward. Railroad service was also cut off, and much of the city went without electricity.

Many of the roads in Holyoke were closed as a result of the hurricane. Downed power lines and fallen trees took several days to clear. It was not until September 23 that enough debris was cleared for life to return to normal again. Pictured here is a Holyoke Street Railway bus trying to make its way down one of the side streets in the Highlands Section of Holyoke, just off of Northampton Street.